IMAGES
of America

CONNEAUT
LAKE PARK

Lynce's Landing,
CONNEAUT LAKE, PA.

This old established favorite picnic ground, at the head of Conneaut Lake, has been greatly improved and now offers superior inducements to picnic parties and pleasure seekers. All the steam and sail boats on the Lake make regular stops at this Landing. The best fleet of row boats on the Lake for hire at lowest rates. Hall, 20 by 100, for dancing, picnicing and shelter. Hot and cold water, ice, stove for cooking, etc. Use of grounds and all conveniences *free*. Best of stabling for any number of horses, with careful attendants.

Parties can secure all desired information by applying on the grounds or addressing

AARON LYNCE, Harmonsburg, Pa.

Even back in 1877 there was some activity on the site that eventually became Conneaut Lake Park. Lynce's Landing was one of the first resortlike businesses built on the property.

IMAGES of America
CONNEAUT LAKE PARK

Michael E. Costello

ARCADIA

Copyright © 2005 by Michael E. Costello
ISBN 0-7385-3779-9

First published 2005

Published by Arcadia Publishing,
Charleston SC, Chicago IL, Portsmouth NH, San Francisco CA

Printed in Great Britain

Library of Congress Catalog Card Number: 2005924698

For all general information, contact Arcadia Publishing:
Telephone 843-853-2070
Fax 843-853-0044
E-mail sales@arcadiapublishing.com
For customer service and orders:
Toll-free 1-888-313-2665

Visit us on the Internet at www.arcadiapublishing.com

To my family.

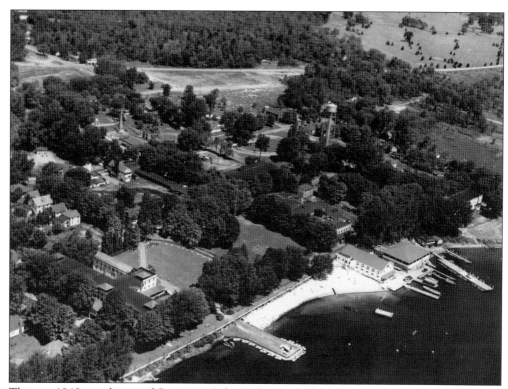

This is a 1948 aerial view of Conneaut Lake Park, a tree-filled amusement resort located at the end of a railroad line and on Pennsylvania's largest natural lake.

Contents

Acknowledgments 6

Forward 7

Introduction 9

1. The Beginning of a Legacy: 1892–1919 11

2. A New Direction: 1920–1943 41

3. Pennsylvania's Perfect Playground: 1944–1973 61

4. The Flynn Era: 1974–1992 97

5. The Next One Hundred Years: 1993 and After 117

Bibliography 128

Acknowledgments

Without the help and support of many individuals, this project would not have been possible. At this time I would like to sincerely thank, in no particular order, Mary Jo and Dave Johnson, Nancy Manning, Jon Horning, Judith Hughes, Carol West, Janey Smith, Jerauld "Smitty" Smith, Frank Miklos, Bill Hrusa, Sarah Hrusa, Louis Muenz, B. Derek Shaw, Patricia Scarmuzzi, Kelly Petrachkoff, Katie Hilton, Don Hilton, Pat Powers of the Linesville Historical Society, Anne W. Stewart of the Crawford County Historical Society, Don Kaltenbaugh, David Hahner, Jim Futrell, Bill Linkenheimer, Rick Davis, Joel Styer, Wally Ely, Jennifer Bixler, Robert Brucker, Julie Hines, Phillip Mansfield, Kelly Lowe, Douglas Poad, Matthew Antonini, Conneaut Lake Business Association, Conneaut Lake Institute Inc., and the Trustees of Conneaut Lake Park. Thank you!

Ode to Conneaut Lake Park

Horray! It's going to open—
>That rickety, rackety,
>Clickety, clackety
>Tumbling, jumbling place
>>Where the carousel thumps
>>and the painted horse pumps
>>though historically none wins a race.

Where the Blue Streak's hills
plunge with shrieking thrills;
And curves lift you out of your seat.
>While below toots the train
>clicking old rails again
>where grandpa can put up his feet.

Grown-up legs try to cram
where the Bumper Cars ram;
Then it's on to the dizzying rides.
>'Til we long for a float
>On the inner-tube moat
>Near watery, tall, splashing slides.

Hey—it's time for Park Fries
And to shoot for a prize
But the best prize would be if we could
>only go back in time
>and be standing in line
for our roll of tickets to childhood.

—Ellie Davies

FOREWORD

The following article was originally published in the *Hay Rake*, a defunct magazine of the Conneaut Lake area. The date of the article is July 1925 and it is titled, "Your Conneaut."

On the porch of the big hotel, I recently dropped into conversation with a gentleman from the west who was spending a weekend here, a stopover on an auto tour east. It was his first visit to America's largest lake resort. He had been walking around the place, visiting the golf links, the aviation field, Temple of Music, the 101 amusements, the beach, the boats and the promenades along the lake. He was very much impressed with Conneaut Lake Park, it was much bigger and finer, costlier than he had expected.

"I wish you'd tell me something," he said. "Who owns all this place?"

"I own it," I replied, immobile as a poker player.

"YOU own it?" said the stranger, gazing at my $22 suit and $4.50 shoes, "YOU own it?"

"Sure," I persisted, "certainly, it all belongs to me."

The stranger drew a long breath and exclaimed, "Well I'll be damned."

As we sat there he kept sizing me up. I could see I didn't look to him like a larger property owner. I haven't "that millionaire expression."

"How long have you owned this place?" he inquired.

"Since I came here, about three months ago."

"Do you figure it's a good investment?"

"The best I ever made."

Another silence ensued. The stranger was thinking.

"You got any partners or anything?"

"Oh yes; there are others interested."

"Do they stay here?"

"Yes. There's one of them sitting on that bench near the lake; the little white-haired lady."

"Her! She doesn't look like a resort owner! How many partners have you got?" The stranger looked at me very quizzically.

"I believe there are about 500,000 of them!"

The stranger glanced about. He had become convinced that he had happened on a lunatic. He wanted to be sure that help was close at hand. After a while, he said, "What did you invest here? How much money have you got in it?"

"Not a dollar. All I invested was interest—others have the principal."

"I wish you would explain," he sighed.

"Well, it is this way. I came here in March and was immediately impressed with the natural beauty of the place, the lake, the land, the park itself, even though it was the worst time of the year for a first sight of it. As spring came on, and then summer, I fell in love with Conneaut Lake Park and all the lovely country that surrounds it. I enjoyed it; I had found a new possession. The person who enjoys and appreciates a thing is the real owner. That is actually true because he is the one who gets most out of it.

"According to the books, court records, deeds, etc., this place belongs to the Conneaut Lake Company," I continued. "The money of the men in this company has built the big hotels, the pavilions, the auditoriums, the golf course, provided the bathhouse and the electric lights. But according to my way of thinking, I own the place a great deal more than any of these men own

it, and so does the little lady with the white hair, and so does every one of the thousands who come here and enjoy all the good things that have been prepared for them.

"I say we own it the most because we enjoy it, get all the best benefits of it—and don't have to pay a darn cent of taxes, insurance, wages, repairs and all the enormous expense of building and maintaining Conneaut Lake Park. We let the 'legal owners' do the worrying about these things, we just take the beautiful place over and exert the squatter's sovereignty of natural rights."

"That's right," said the stranger. "I get your idea. I believe I'm acquiring an interest in Conneaut Lake myself. Isn't that moonlight on the water beautiful? That belongs to me, doesn't it? And this grand hotel—it's mine too, my residence just now. I'm enjoying it, getting the good of it. Yes, it's the truth; everybody who comes here and enjoys this wonderful place owns Conneaut Lake Park. It's all yours; it's all mine, and it belongs to 500 others without cutting down our profits.

"When I first began talking to you," the stranger continued, "I thought you were a rich man. Well, it turned out that I was right here. But I had no suspicion that I was a rich man too, and a partner in the same concern."

* * *

Few are left: the rural, summer-resort amusement parks, where generations of Americans escaped the noise, congestion, and stress of everyday life. There were hundreds of them, scattered over the countryside, generally at some place of natural beauty, often a lake. They have been replaced by the giant parks, where the visitor's experience is carefully planned and programmed, and buildings and settings are themed to imitate and re-create. Traditional amusement parks evolved over time, adapting to new architectural styles and themes of public interest. Like the trees, they grew and became part of the rural landscape. The few that remain are tangible reminders of the link between the past and present.

Conneaut Lake Park is unique. It is a traditional amusement park founded in 1892, but it is also a town with more than 100 private residences. The park is part of a cultural landscape; a resort area created by the natural beauty of Conneaut Lake, the commonwealth's largest natural lake. The park's buildings, a mix of architectural types and period styles, and an array of vintage rides, give it a character all its own. Add to these things the fact that the park is owned by the people, not a large corporation, and its rarity is even more apparent.

Generations of visitors came to Conneaut Lake Park and left with souvenirs and memories. People from Pittsburgh formed the largest customer group. Steelworkers brought their families on vacation to escape the noise, congestion and stress of city life. Area families came for the day to picnic, swim, and enjoy the rides. Today, despite the competition of giant theme parks, Conneaut Lake Park continues to work its special magic. The architecture and setting evoke the feeling of something permanent and authentic, not a themed imitation, but the real thing. Today, just as for earlier generations, the tree-covered midway, the vintage buildings, the special amusement park sounds and smells, and the view of the lake, all combine to create an atmosphere that cannot be duplicated. Conneaut Lake Park is a unique piece of rural Americana.

—Carl K. Burkett Jr.
Member, Board of Trustees
Conneaut Lake Park

INTRODUCTION

In the resort community of Conneaut Lake and on Pennsylvania's largest natural lake lies a quaintly familiar amusement resort known as Conneaut Lake Park. Pleasure-seekers first started coming here in 1877, when a businessman named Aaron Lynce first owned the property. It was then known as Lynce's Landing and offered a boat landing, a dance space, food, and livery services. In 1892, a visionary named Col. Frank Mantor saw potential for the property, purchased the adjacent McClure Farm, and found investors from the Bessemer and Lake Erie Railroad who were interested in extending their railroad line to a newly formed resort. Exposition Park began as a permanent summer fair that offered athletic fields, convention facilities, restaurants, shops, a couple of primitive amusement rides, numerous hotels, cottages, and a bathhouse to accommodate freshwater bathing.

In the early days, before auto roads were constructed, railroad service and ferryboats on the lake were the main modes of transportation to the resort. Because the trains only ran on weekends, people would go to the resort and stay all week in any of the resort's dozen hotels. In 1908, over half of the park was destroyed in a fire that burned hotels, most of the midway buildings, the dance hall, bowling alley, cottages, and damaged the Figure Eight coaster. After the fire, management took advantage of the opportunity to rebuild the midway with more substantial concrete-block structures. One new building was a dance pavilion, later renamed the Dreamland Ballroom. During the 1920s, the look of the resort began to change as more mechanical amusement rides were added. As a result, the fairground type of resort began to look more like an amusement park, and for that reason, the name was changed to Conneaut Lake Park.

During the Great Depression, the resort began a gradual decline, and in 1933 the Peoples-Pittsburgh Trust purchased the park for $35,000, freeing it from bankruptcy. The new owners started expanding by adding the Beach Club nightclub and boardwalk, a new water tower and water system, and the Blue Streak roller coaster. In 1943, half of the resort's 300-room Hotel Conneaut was lost in a fire. The following year brought new management and ownership. The new management team included E. E. Freeland, Dr. Harry E. Winslow, Harry Kleinhans, T. C. Foley, and Charles J. Miller, and was best known for the hands-on leadership of Elmer E. Freeland. During this era, Conneaut Lake Park found itself in the middle of the mega–theme park era, and management modified some borrowed ideas for Conneaut Lake Park. As a result, themed attractions such as Fairyland Forest, Kiddieland, and the Jungle Cruise opened, and a new Ride-A-Rama, pay-one-price-for-rides system, was instituted. In 1974, Mary Gene Windslow Flynn, the daughter of Dr. Harry Windslow, took control after her father died. She ran the park until she passed away in 1981 and her son Charles Flynn took over.

The next few years saw some changes to the park, with the addition of water slides, the renovation of the 1910 Carousel, and the demolition of many of the 1909 cement-block midway buildings in the front of the park. The most notable change occurred in 1990, when the park was enclosed in a fence and a first-ever admission fee was charged, along with parking fees. These changes, which led to a strong decline in the park, created lasting effects to this day. In 1992 the park celebrated its 100th anniversary. At that time, Charles Flynn made the decision to auction off most of the rides and change the format of the park. The idea was to keep a few of the rides, including the carousel, the Dodgems, the train, and the Kiddieland rides. The Blue Streak would be demolished and the other rides would be sold in an attempt

to focus more on water slides and large concert venues. The community did not welcome these changes, and as a result, 7 local businessmen purchased 11 of the 17 rides at auction, along with the rest of the park, to keep the traditional feel of the resort intact. While renovating the park and making major infrastructural upgrades, the new owners were unable to run the park without a loss. After a nearly $1 million operating loss over those seasons, the resort failed to open for the 1995 summer season—for the first time in the park's 103-year history.

By mid-summer 1996, a group called Summer Resorts Inc. purchased the park for $2 million. When all seemed to be going well for the park, the owners were having legal problems of their own and made the decision to donate the park to the community. Conneaut Lake Park became a public trust, held for the people of northwest Pennsylvania, and operated by a board of trustees.

The individual who first started bringing pleasure-seekers to this piece of land was an entrepreneur named Aaron Lynce. In 1877, he started a simple boat landing and livery service on some lakefront property adjacent to the old McClure Farm. It was Lynce's Landing and the McClure Farm that eventually became Exposition Park and then Conneaut Lake Park.

One
THE BEGINNING OF A LEGACY
1892–1919

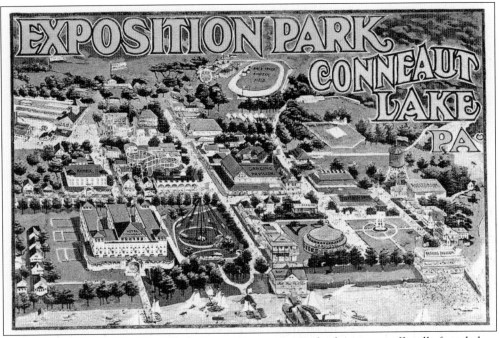

Conneaut Lake Park was originally known as Exposition Park when it was officially founded on August 15, 1892. This view shows the layout of the resort c. 1906.

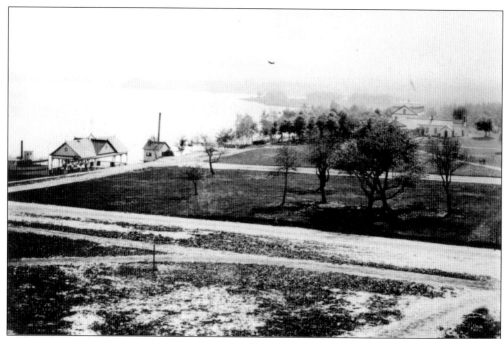

This very early view of Exposition Park, taken from atop the auditorium, shows how primitive the resort was before any major development took place. In the distance is the Exposition Hotel, constructed in 1893. That site eventually became the location of Hotel Conneaut. The vessel docked at the boathouse was known as the *Keystone*. (Crawford County Historical Society.)

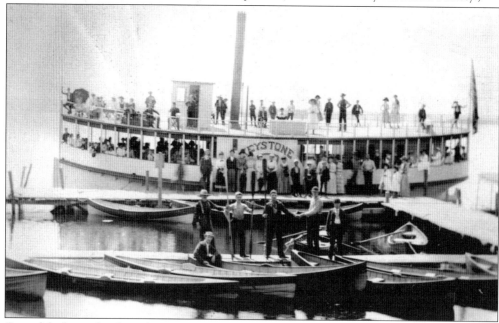

One of the boats that brought vacationers to Exposition Park was the *Keystone*, a wooden, side-wheeled vessel that operated from 1881 until 1893. Here, the boat is moored at the resort's boat docks. These passenger boats were large party boats, able to accommodate considerable numbers of people. (Crawford County Historical Society.)

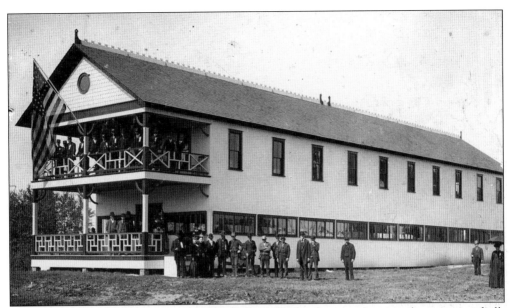

This ornately decorated structure could quite possibly be the resort's original convention hall, which was built in 1893. It is also quite possible that this structure was eventually moved across the park and attached to the Exposition Hotel. If so, this structure was later used in the rebuilding of the Exposition Hotel into Hotel Conneaut in 1903.

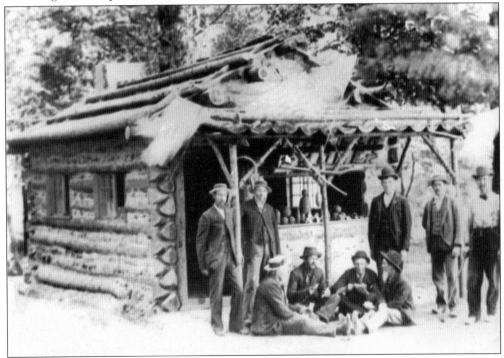

One of the earliest refreshment facilities at Exposition Park was the Log Cabin. Proprietor R. C. Jackson advertised the Log Cabin as a wholesaler and retail dealer of gilt-edged ice cream, sweet milk, cream, and buttermilk. The resort has had the Log Cabin since these very early days. (Katie Hilton Collection.)

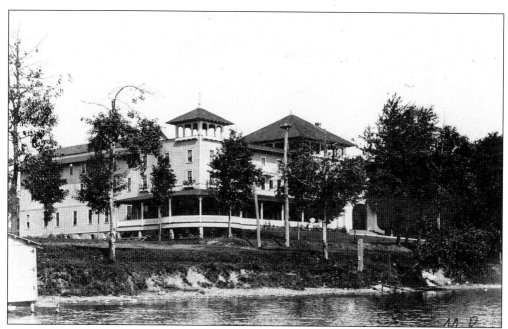

New for the 1903 summer season was this massive 300-room hotel known as Hotel Conneaut. This hotel was the center of accommodations at the resort, just as its predecessor, the Exposition Hotel, had been. Although considered the best the resort offered, it did not have bathtubs in the guest rooms, and instead offered community bathtubs in a little room at the end of each hall.

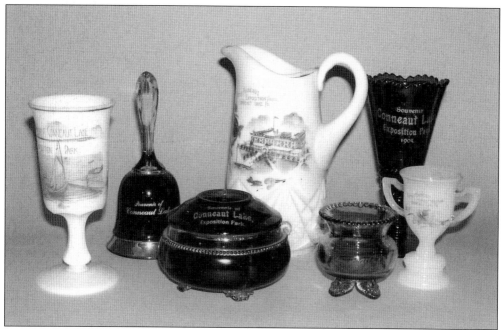

Pictured is a small sampling of the numerous types of glass souvenirs that were sold at Exposition Park. The glass souvenirs from Exposition Park seem to be as high in quality and variety as those sold at any other amusement park in the country.

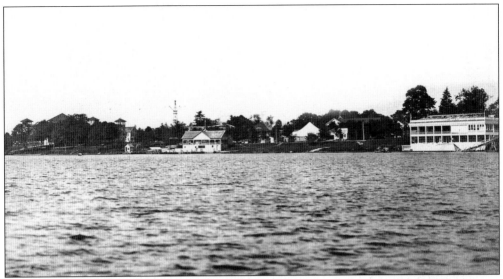

This view from Conneaut Lake reveals what an impressive skyline the resort had at a time when amusement rides were a novelty. The structures seen on the shoreline are, from left to right, Hotel Conneaut, the icehouse, the Circle Swing, the boathouse (the Figure Eight roller coaster is behind it), an unidentified structure, the canvas-top carousel, the dance pavilion, and the bathhouse.

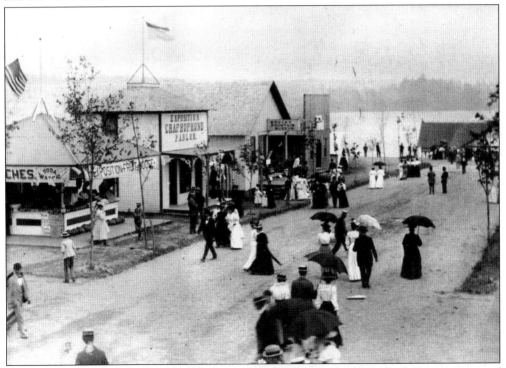

This view from the resort's original bowling alley shows the main drag, Park Avenue—one of the first formations of a midway at the resort. Exposition Park looked more like a small town with streets and buildings than a park. The third building from the left housed the Rocky Mountain Museum.

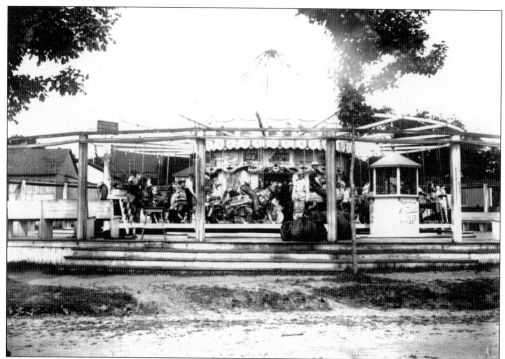

The first amusement ride to appear at the resort was this primitive steam-powered carousel, built on the edge of the park and overlooking the lake. This carousel featured a ring machine that dispensed rings that riders on the outside row of horses would reach for and catch. The rider who caught the one brass ring would win a free ride. This photograph was taken in 1899. (Linesville Historical Society.)

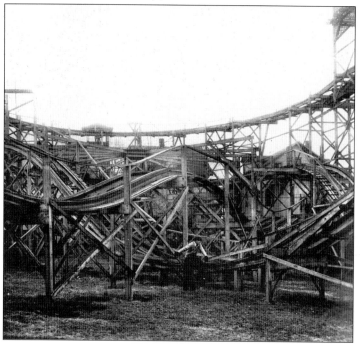

The park's first roller coaster was built by the Fred Ingersoll Company of Pittsburgh, and was known officially as the Three-Way Figure Eight Toboggan Slide. Later, the coaster was renamed the Jack Rabbit, before it was demolished in 1936. Early in the 20th century, a few different firms built numerous coasters with this same layout and design at many amusement parks around the country.

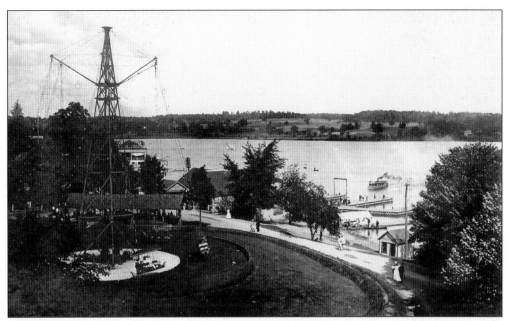

The tower structure on the left in this photograph was the Circle Swing, a primitive amusement ride where riders sat in wicker gondolas that hung from cables attached to the top of the central column. The ride was a spectacle at night, and its lightbulb-lined support cables were visible from all over the lake.

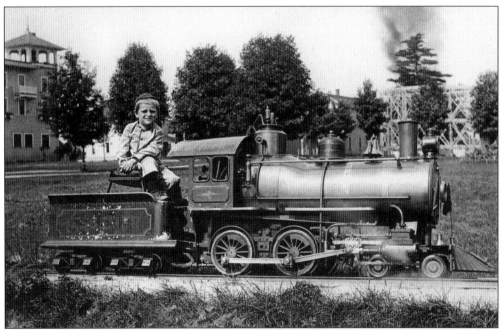

The resort's first miniature railroad ride, then known as the North-Western Line and operated by the Miniature Railroad Company, circled the commons from about 1904 until 1910. In the background of this photograph, Hotel Conneaut and the Figure Eight roller coaster are visible. This photograph was taken on July 27, 1904. The "train operator" was six-year-old Arthur F. Lowrie. (Frank Miklos Collection.)

17

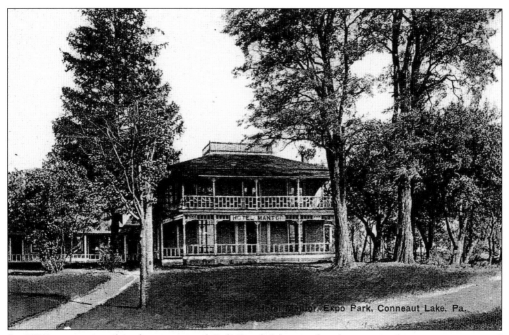

In 1897, two years after the passing of Col. Frank Mantor, his former residence was converted into the Mantor House. Before the colonel resided in the building it was the McClure farmhouse, built in the 1850s, and later, the Echo Hotel.

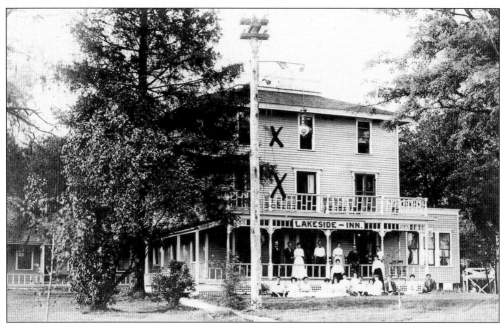

In 1906, the Mantor House was renamed the Lakeside Inn upon the addition of a third floor. The hotel stopped hosting guests in the 1960s, when it was converted into an employee dormitory.

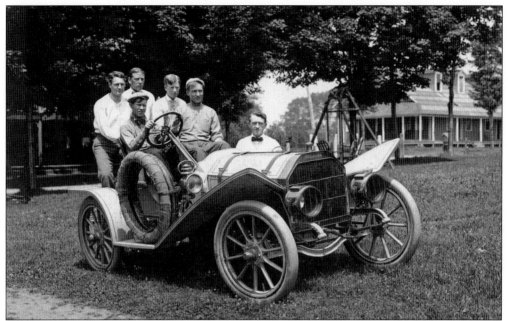

W. W. Wilt, a photographer who had a studio at the resort, often took personal souvenir photographs for Lake Conneaut guests, in addition to the many promotional photographs he took of the resort. The automobile these gentlemen are posing on probably had a rough ride since there were no paved roads yet leading to the resort. In the background, the Elephant Cottage is visible.

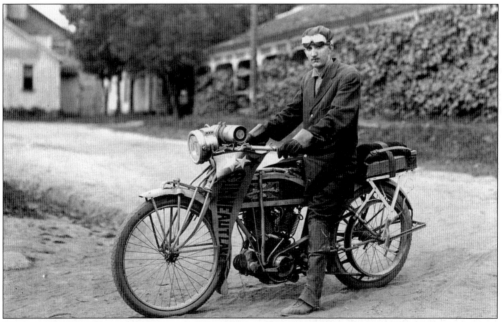

This unidentified gentleman posed for a souvenir photograph on a motorbike called an Auto Cycle. Souvenir photographs often featured pennants in the view, similar to the one seen here. In the background are the corner of the auditorium (on left) and the veranda of the Aldine Cottage (on right).

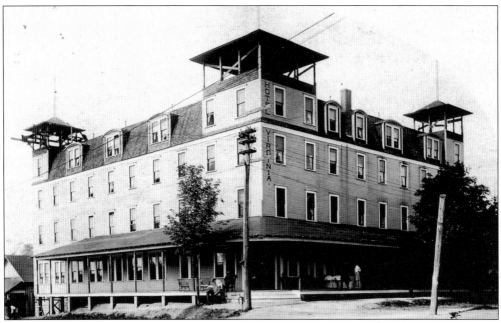

The Hotel Virginia, built directly behind Hotel Conneaut, helped the resort keep up with increasing demand for accommodations. While Hotel Conneaut was three stories tall, the Hotel Virginia had four stories and was decorated with cupolas that increased the building's size to five stories. The Hotel Virginia was among the tallest buildings that ever stood in the resort.

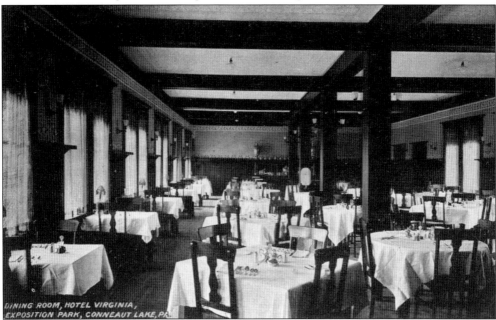

The elegant dining room of the Hotel Virginia offered on its menu, in 1915, vermicelli soup, consommé clear, broiled blue pike and brown potatoes, larded fillet or beef with mushrooms, stewed veal with egg dumplings, baked pork and beans, bread pudding with wine sauce, roast prime rib au jus, potato salad, mashed potatoes, spinach, red raspberry pie, baked rice pudding, ice cream, cream cheese, tea, coffee, postum, and milk.

This charming Victorian structure was known as the Bismark Hotel. Misfortune struck the Bismark in December 1908, when it burned in a fire.

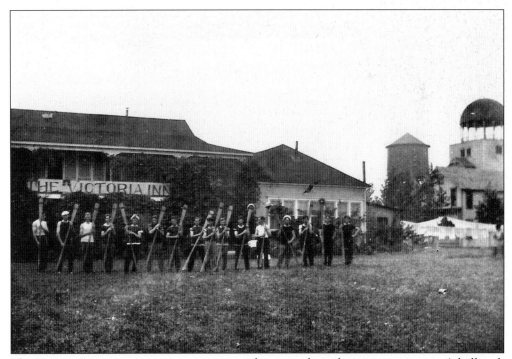

The Victoria Inn was a two-story structure with a veranda outlining its perimeter. A hallmark of Conneaut Lake hotels had always been long verandas, perfect for relaxing and enjoy it all.

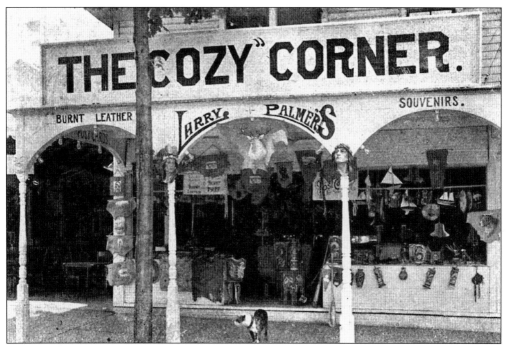

The Cozy Corner was a souvenir shop that was located on Park Avenue. It faced the large grassy area overlooking the lake known as the commons. Although the shop burned in a 1908 fire, it was rebuilt in 1909.

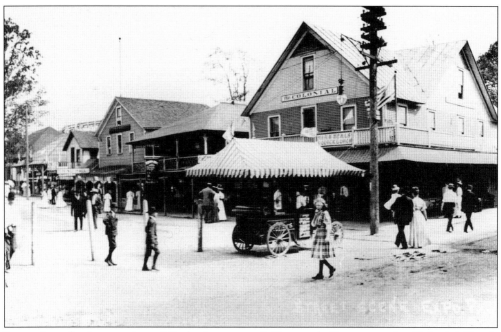

Located at the intersection of Park Avenue and Comstock Street was the Colonial Hotel, complete with a restaurant on the first floor. Although it was called a hotel, the Colonial was actually the size of a small inn or bed-and-breakfast. This structure burned in a 1908 fire. (Crawford County Historical Society.)

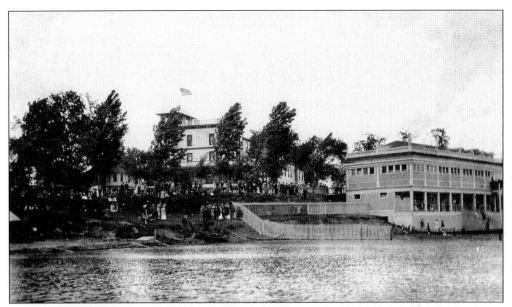

In about 1915, J&S Reany, proprietor of the Lakeside Inn, built the Reany Hotel, which can be seen at center, hidden behind the elm trees blowing in what looks like a heavy wind. Because of these elm trees, the Reany was later renamed the Hotel Elmwood. To the right in this photograph is the bathhouse.

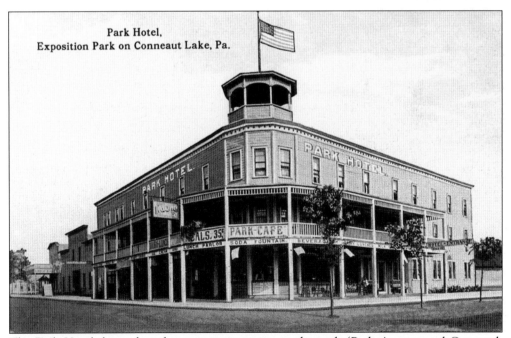

The Park Hotel, located at the main intersection in the park (Park Avenue and Comstock Street), first opened in 1910 and in 1928 was renamed the Antler Hotel. Notice the concession style refreshment stands on the hotel's ground level, which were the result of the hotel's location on the main midway. Although not in service at the time, it burned down in 1932.

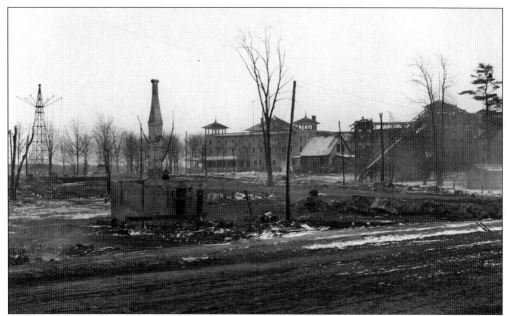

On December 2, 1908, a fire in one of the early hotels spread and destroyed nearly half of the park. Pictured here are, from left to right, the Circle Swing, Hotel Conneaut, a cottage, the Figure Eight roller coaster, and the Hotel Virginia, all of which survived the fire. The Figure Eight, however, was heavily damaged and suffered the loss of its loading station and cars. Notice the wheel below the Circle Swing, which was evidently part of the operating machinery in the Old Mill dark ride. (Katie Hilton Collection.)

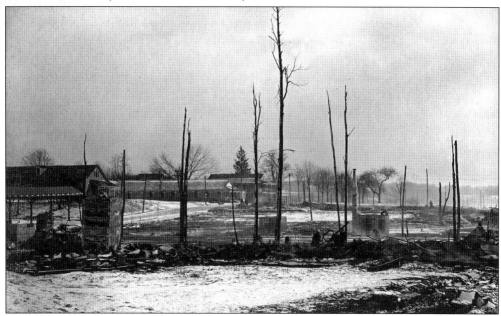

Visible in this photograph taken after the fire are, from left to right, the trolley station, Elephant Cottage, Aldine Cottage, Victoria Cottage, and Lakeside Inn, all of which were also survivors of the fire. Even after the remains of the structures that were destroyed in the fire had been covered with snow, they continued to smolder, as is evident in this view. (Katie Hilton Collection.)

Between 1910 and the 1930s, the middle of Center Street, on opposite sides of Park Avenue, featured the Sunken Gardens—an area depressed about three feet below the surface of the street. These highly landscaped gardens were fenced off, but there were stairs so patrons could climb down into them and wander around their tiny paths. (Katie Hilton Connection.)

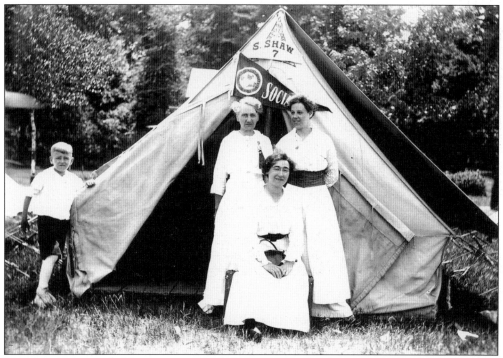

Many organizations held various outings at Exposition Park. This photograph is from a socialist conclave held at Exposition Park in 1915.

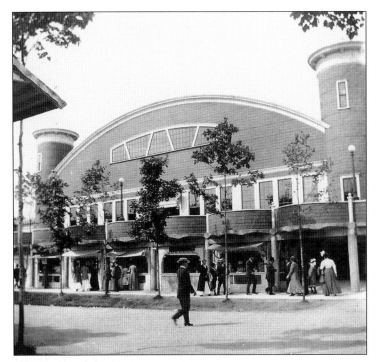

To replace the original dance pavilion that was lost in the fire, a brand-new steel and concrete pavilion was built, which included concession stands on the ground level and a dancing facility on the second floor. Its roof was covered with red tin and its exterior coverings consisted of tin sheets made to look like green-stained cedar.

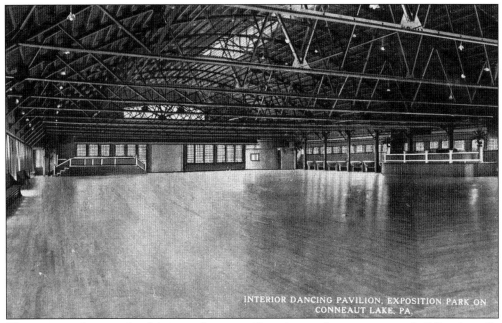

This interior photograph of the new dance pavilion shows what a cavernous building it really was. Due to its maple flooring and 20,000 square feet of dancing space, it was considered to be the largest and best dance pavilion in the Midwest. In later times, it was renamed the Dreamland Ballroom. (Crawford County Historical Society.)

In the aftermath of the fire, management saw a great opportunity to expand and strengthen the infrastructure of the resort like never before. The old midway buildings were replaced with more-substantial, concrete-block structures, which remained until they were demolished in 1992. Notice the brand-new boathouse at the end of the midway and the American flags on all the buildings.

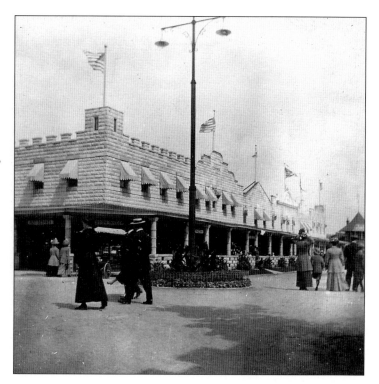

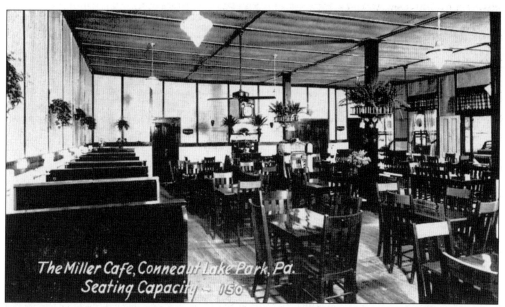

Located at the far corner of the midway buildings was the Miller Cafe. John Miller and Sons, proprietors, advertised their eateries as the "most popular on the park." The Millers were also proud of the Miller Cafe's large seating capacity, as noted on this early postcard. It was in this same building that the famous Conneaut Lake Park french fries were made and sold in later years. (Katie Hilton Collection.)

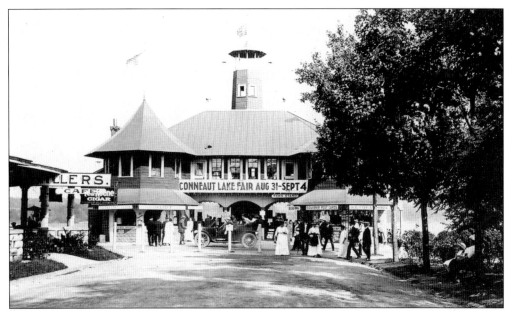

Right across the street from the Miller Cafe was the brand-new, open-air boathouse, which included the offices of the Conneaut Lake Navigation Company on the lower level and a cafe on the second floor. The cafe advertised the sale of Chinese dishes, and chicken and waffles. Notice the souvenir postcard stand with its rows and rows of postcards, which remained as reminders of these earlier days for the next century.

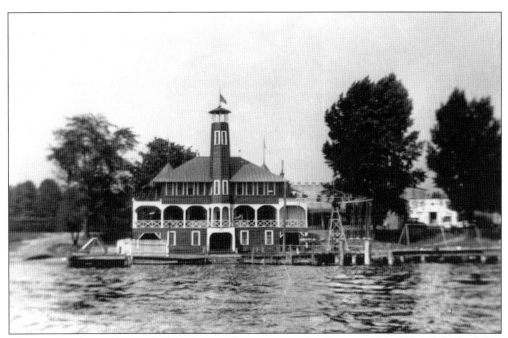

The new boathouse featured a lighthouse-like tower as a focal point on the side of the building that faced the water. Notice the swing ride, which was an early version of the YoYo ride. (Crawford County Historical Society,)

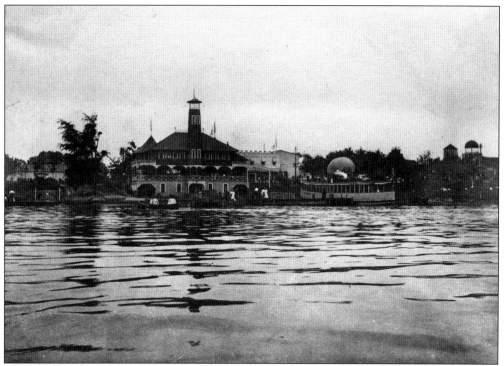

This photograph shows a very busy Exposition Park. At the time this photograph was taken, the steamer *Pittsburg* was docked and the Thurston balloon was getting ready to launch. Notice the old wooden water tower and the auditorium's cupola to the right.

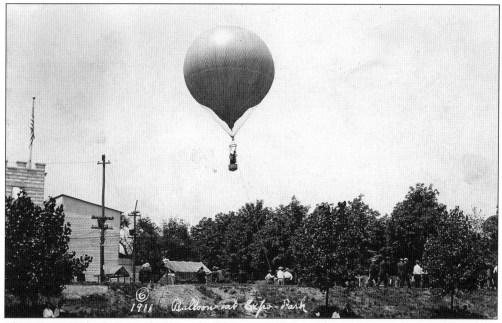

This W. W. Wilt photograph shows the Thurston balloon tethered at Exposition Park in 1911. Nearly a century later, the Thurston Balloon Classic was held in the area.

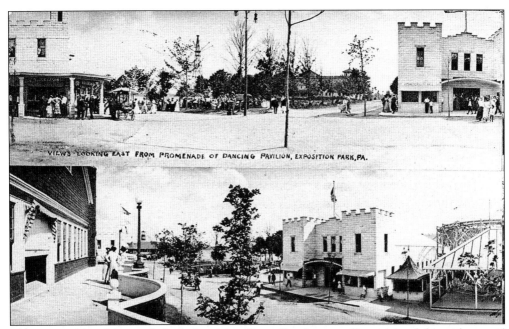

The promenade of the newly built dance pavilion offered an excellent view of the midway and the castle-like bowling alley building, which was made of concrete block, indicating that it was a post-fire construction. It replaced the original bowling alley that burned in the fire. To the right was the Figure Eight, sporting its new loading station, which replaced the station lost in the fire.

In 1899, the resort started publishing many promotional brochures and booklets. As time progressed, the material became more colorful and eye-catching.

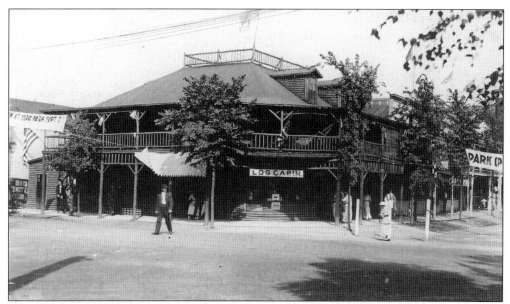

The original Log Cabin was replaced by a newer two-story structure that soon burned in the 1908 fire. This view shows the third incarnation of the Log Cabin, which lasted until the 1960s, when it was replaced by yet another Log Cabin.

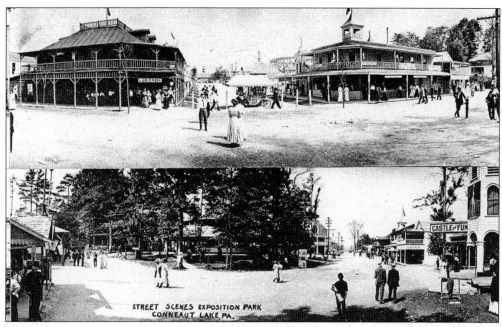

This split-view postcard shows the Log Cabin and the new Colonial Restaurant in the top view; and in the bottom view, the train depot, the new merry-go-round, and the Castle of Fun fun house.

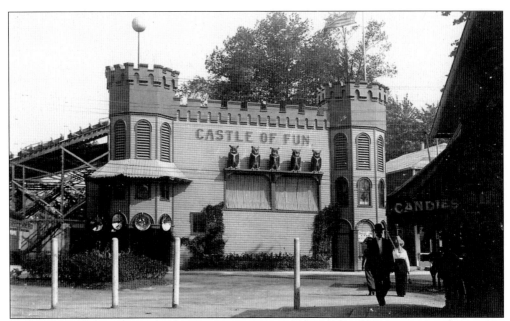

The Castle of Fun was one of the first attractions guests would approach upon arriving at the resort. It was a walk-through fun-house type of attraction, complete with slides, revolving barrels, and the like. Originally, this building housed the Theatorium, a theater showing motion pictures. Later, during the 1950s and 1960s, the attraction was known as the Crazy Maze, and featured Laughing Sal, a mechanical woman that laughed all day with the help of a record player.

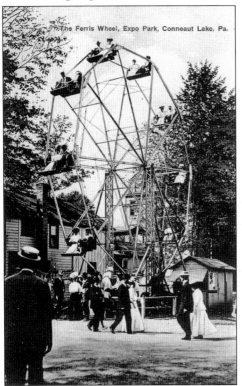

The first Ferris wheel at Exposition Park was this 10-seater ride, built by the Eli Bridge Company. Eli Bridge was and still is one of the largest manufacturers of Ferris wheels, many of which continue to operate at amusement parks, fairs, and carnivals.

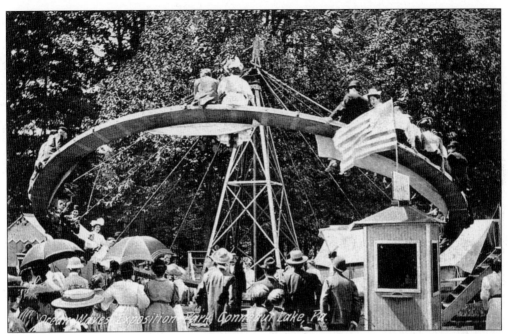

The Ocean Waves was a simple contraption that would certainly defy modern safety standards. Patrons appear to be hanging on for their lives.

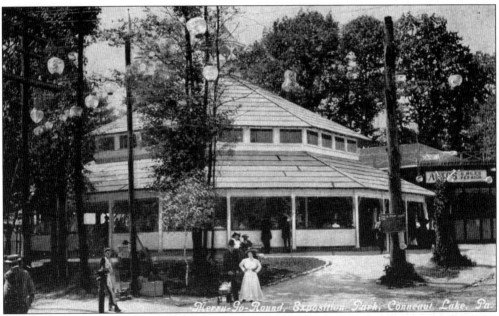

In 1910, the new carousel was placed in a brand-new building, situated on the southwest corner of Park Avenue and Comstock Street. Though this ride was built by the D. C. Mueller Company, it was held as a concession of the T. M. Harton Company. The new carousel featured a recently invented mechanism that allowed the horses to move up and down as the carousel spun, a feature that the previous ride did not offer.

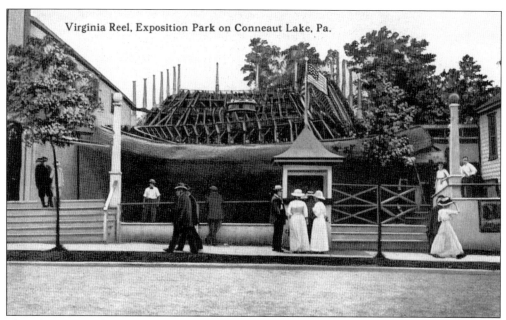

The Virginia Reel was a coaster-like ride that pulled circular cars up an incline before they zigzagged their way back to the bottom. This ride only lasted a few seasons at the resort before it was dismantled.

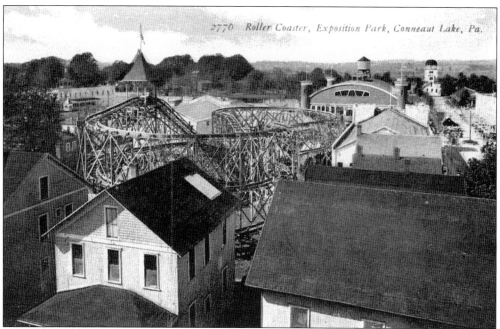

This photograph of the Figure Eight roller coaster shows its close proximity to the cottages surrounding it. The coaster cars literally whizzed past the windows of the cottages. This coaster was different from modern-day coasters in that it did not have under-track friction wheels to keep the cars from leaving the track. Instead, it featured a trough-shaped track with wheels on the underside and sides of the cars. As a result of this design, riders would experience mild dips of only nine feet or so, and a slight side-to-side motion.

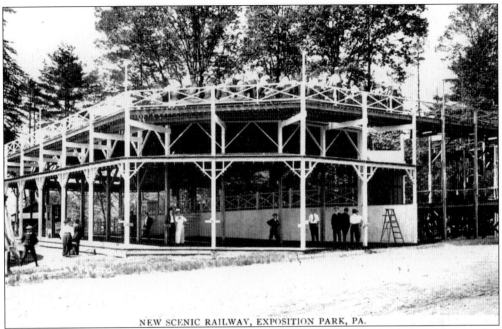

The scenic railway, sometimes called the Big Chute Scenic Railway, was built through a wooded section of the resort in 1909; its station was on Park Avenue. This ride was another side-friction-type coaster, but it featured much bigger hills and a longer ride than the Figure Eight.

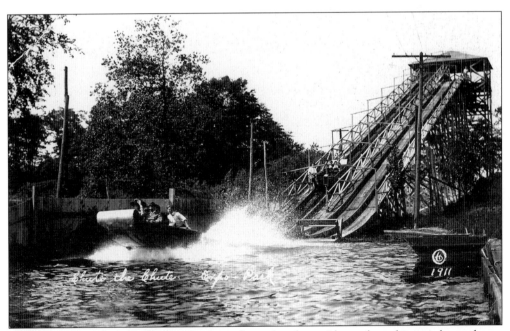

Forerunners to today's log flume rides were chute-the-chute rides such as this one, located on a site later occupied by a pony track, and even later, by a convention hall. This photograph was taken in 1911 by W. W. Wilt.

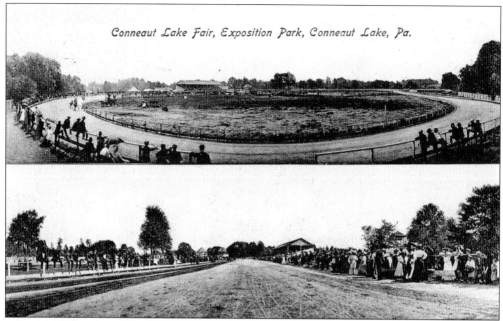

The racetrack was one feature of Exposition Park that made it fit into the category of an exposition or fair, although the track opened 13 years after the founding of the resort. As pictured below, the annual Conneaut Lake Fair was once held at this location. Eventually, the property was used as a parking lot.

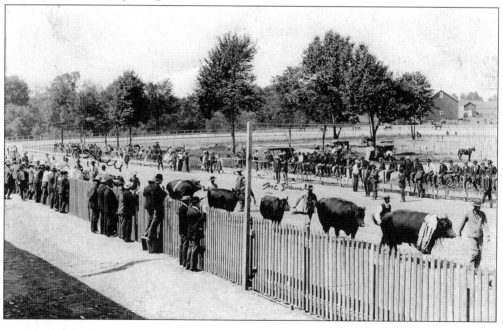

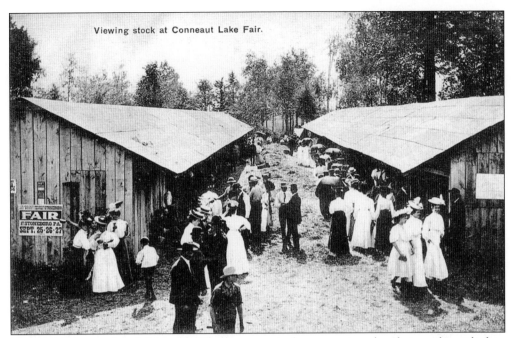

These early livestock exhibition stables were yet another attraction that fit into the early fair-like format of Exposition Park. These stables were located on the fairgrounds of the resort, which later became Fairyland Forest, and even later, Camperland.

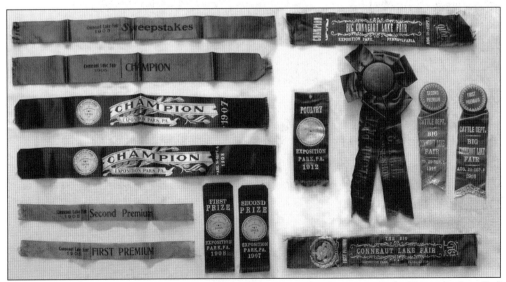

These are ribbons from various competitive categories at the Conneaut Lake Fair, which called Exposition Park home during this era.

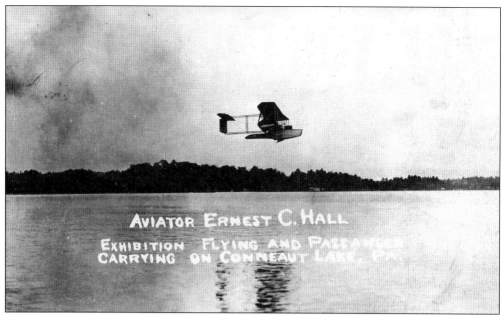

Pilot Ernest C. Hall gave this photograph as a souvenir to those who paid to ride the airboat. Hall was a pilot who made tremendous contributions to the advancement of aviation, and he started a flight school on Conneaut Lake. This real-photo postcard was a souvenir kept by someone who flew with Hall in September 1915.

One of the biggest draws to this new lakeside resort, situated on Pennsylvania's largest natural lake, was the wonderfully clean and clear water. Proper bathing attire at the time consisted of these woolen swimming dresses. Swimmers pose on a primitive contraption sometimes called the Toboggan Slide. Wooden vehicles loaded with fun-seekers would descend down the wooden track down before plunging into Conneaut Lake.

ARE YOU LONESOME?
GO
ROLLER SKATING
AT EXPO PARK ROLLER RINK
CONNEAUT LAKE, PA.

Where Skating is WORTH WHILE

The resort was equipped with a skating rink located at the southwest corner of Reed Avenue and Comstock Street during the 1920s and 1930s. The resort used some rather interesting advertising techniques. Skating later moved into Dreamland Ballroom.

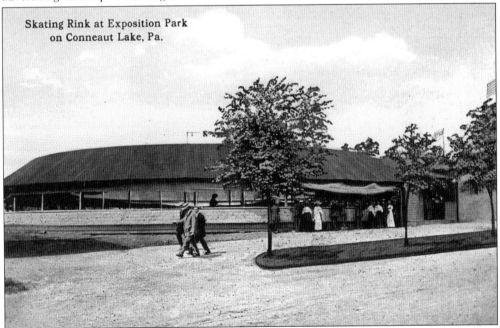

Skating Rink at Exposition Park on Conneaut Lake, Pa.

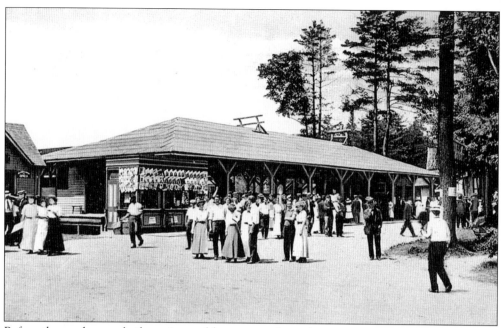

Before the roads were built, trains and boats were the only transportation to the resort. The owners of the Pittsburgh, Shenango, and Lake Erie Railroad knew that extending their line and building a resort at the end of it would cause more people to patronize the railroad. This depot stood at the end of the line, in the middle of Exposition Park.

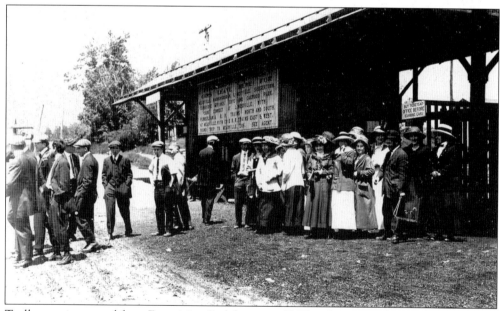

Trolley service to and from Exposition Park began in 1907 and continued into the 1920s. This photograph, which was taken on June 2, 1913, shows students from a biology class at the trolley station during a trip to Exposition Park.

Two
A New Direction
1920–1943

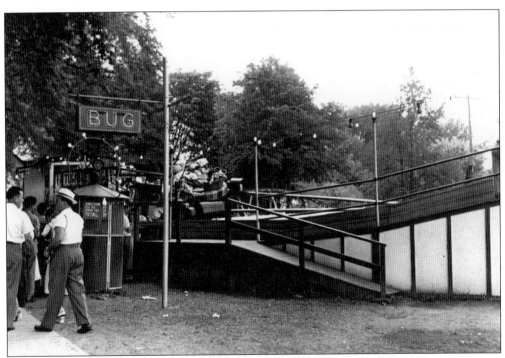

The focus of the resort began to change as rides like the Bug were installed, causing Exposition Park to fall into the category of an amusement park rather than an exhibition or fair. Because of the ever-growing popularity of amusement rides during this era, management continued to add such attractions and subsequently changed the resort's name from Exposition Park to Conneaut Lake Park.

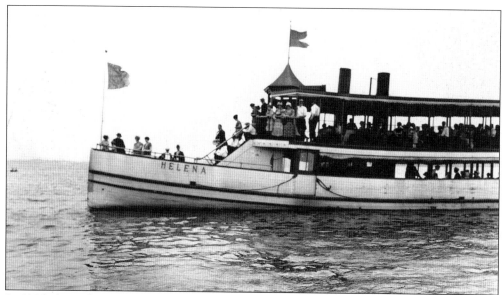

In 1905, the *Helena* was built. It was the largest passenger boat on the lake, with a capacity of nearly 200 people. When this photograph was taken in 1924, the *Helena* had already been extremely modified with the addition of a second deck. By 1937 the boat had been out of service for a few years and was burned by the Conneaut Lake Navigation Company. (Crawford County Historical Society.)

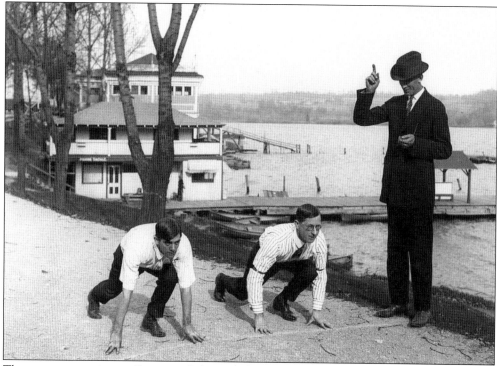

These men are racing at Conneaut Lake Park during the off-season for unspecified reasons. In the background of this view, the bathhouse and the Toboggan Slide are visible. (Crawford County Historical Society.)

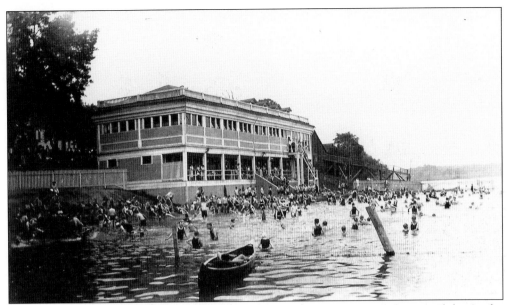

By the early 1930s, the bathhouse was showing its age and so was the Toboggan Slide. At the time of this photograph, a portion of the slide was missing or had possibly collapsed.

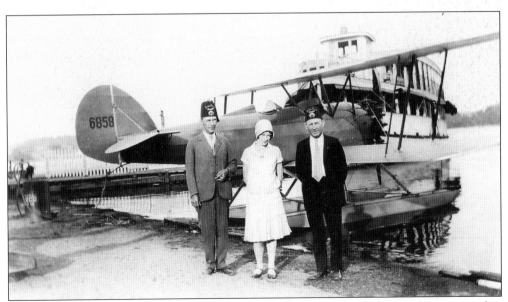

The three individuals in this July 25, 1928 photograph are unidentified, but it is apparent that they were in town to attend the Shriners' convention being held at Conneaut Lake Park. Seen behind them are a seaplane and the steamer *Pennsylvania*.

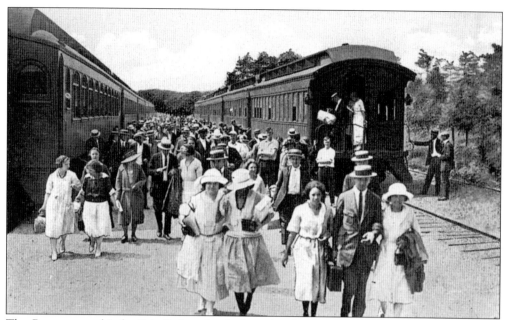

The Bessemer and Lake Erie Railroad only brought chartered excursion trains to Conneaut Lake Park during the 1930s, a time when the resort was struggling. The tracks were rarely used for excursions in later years. The last trains traveled to the resort in 1971.

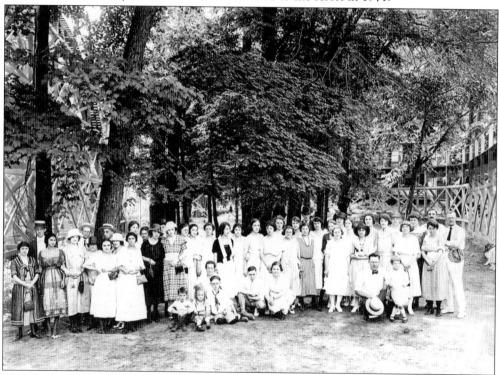

This photograph is from the fourth annual picnic of the Warren and Niles Company Traffic Department, held at Conneaut Lake Park on July 17, 1921. Notice the tracks of the Scenic Railway in the background.

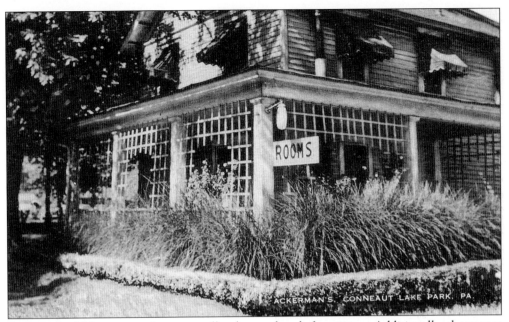

Early in the 20th century, the resort offered many hotels for visitors. Additionally, there were many private cottages around the resort. Some of those people who owned the cottages stayed in them during the summer months and rented out single rooms to guests. Akerman's was one of the many cottages that remained at the resort into the 21st century.

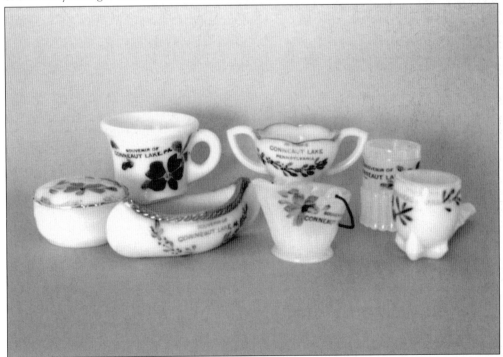

Glass souvenirs such as these were sold at Conneaut Lake Park during the 1920s and 1930s. The glass souvenirs of this period were much cruder than those sold at the resort during the Exposition Park years.

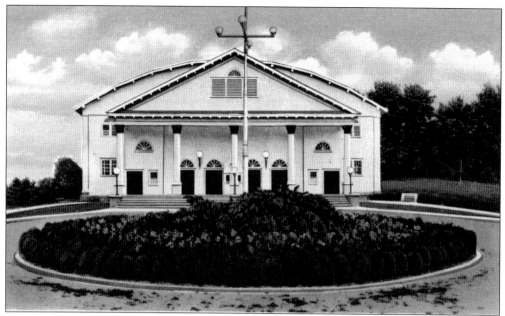

A new addition in 1925 was the $100,000 Temple of Music. The construction of the theater was a community happening that the locals were very proud of. The Temple of Music came to a very unfortunate end on June 7, 1946, when it burned to the ground.

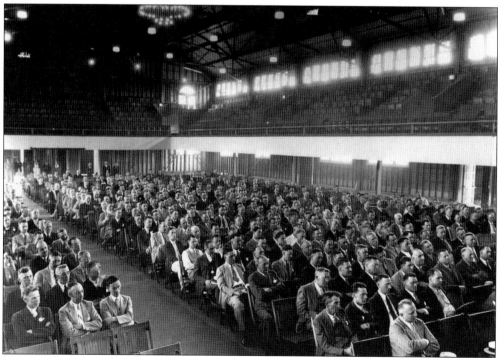

The Temple of Music was a colossal structure. Constructed with a seating capacity of 5,000 and a 64-foot-wide stage, it truly was the center of cultural activities in and around the area. The group in this photograph is unidentified.

MAX SCHMELING
WORLD'S HEAVYWEIGHT CHAMPION
TRAINING CAMP
CONNEAUT LAKE PARK, PENN.

May 27 1931

NOW TRAINING TO MEET
W. L. STRIBLING, JR.
OF GEORGIA, U. S. A.
FOR WORLD'S HEAVYWEIGHT CHAMPIONSHIP
--15 ROUNDS--
CLEVELAND, OHIO
JULY 3RD, 1931

Sch/r.

Mr. Wycliffe Gordon Knight,
P.O.B. 841,
El Paso, Texas.

Dear Sir:-

I am in receipt of your kind letter and send you enclosed an autographed photo which you requested.

With best wishes

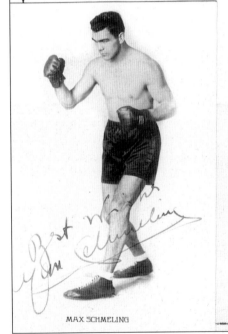

MAX SCHMELING

In 1931, heavyweight champion Max Schmeling sponsored a training camp in the Temple of Music. Because the seats on the ground floor were mobile folding-chair units, clearing the ground level for such events was done with ease. This signed letter, on the Max Schmeling Training Camp's embossed letterhead, was mailed with an autographed photograph to a fan.

Park Pharmacy

OPPOSITE BESSEMER STATION
CONNEAUT LAKE PARK, PA.

Beside a cozy and comfortable place to meet your friends and enjoy a refreshing glass of cool Soda Water, a delicious Egg Drink, a plate of palatable Ice Cream, or eating some of our Reymer's Candies and to sit on an easy, comfortable chair, you will have ample opportunity to gaze about and see our well supplied Drug Stock and Sundries. Toilet preparations and special lotions for Sunburn are here also. You'll want to surely visit this store often, once you come around.

O. A. SPEAKMAN, Prop.

It might seem odd for an amusement park to have a pharmacy, but it was necessary for the living community within the park and its visitors. The Park Pharmacy, as it was called, stood across from the train station for many years. (Katie Hilton Collection.)

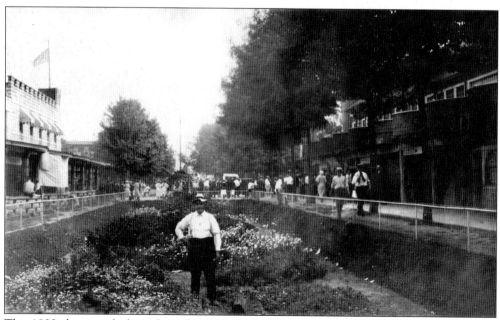

This 1932 photograph shows how the Sunken Gardens appeared shortly before their removal.

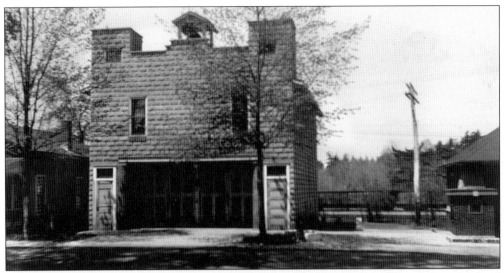

Conneaut Lake Park truly was a little town, complete with its own post office, train station, and firehouse. This firehouse was constructed of the same concrete blocks as the other midway buildings built after the fire. It remained the park's fire station until a new one was erected on Route 618 in the 1970s.

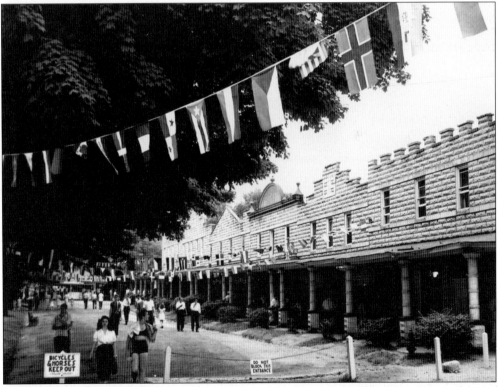

By the 1950s, the park began to mature and take on its own personality. The upper midway of the park, decorated with grand shade trees, looked virtually the same until 1992, when the familiar concrete-block midway buildings were demolished. Notice the sign telling visitors that bicycles and horses are not welcome.

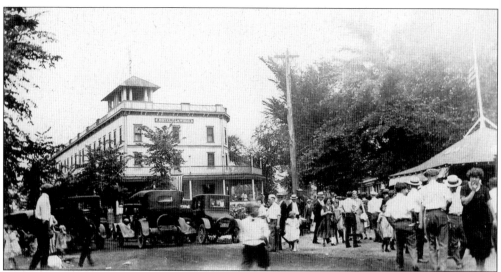

The Hotel Elmwood was famous for having one of the best lake views of all the lake hotels, and also for its maple flooring in the dining room. Some might remember the obvious lean of the dining room wall, which had managed to shift out of position some time during construction.

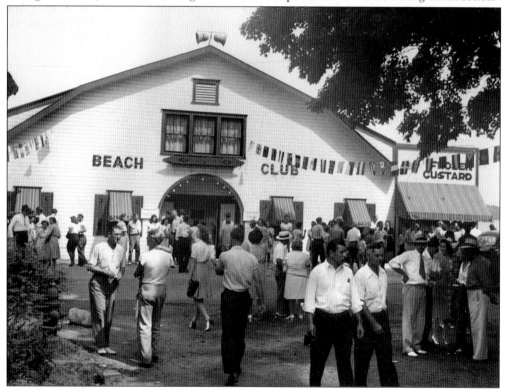

New for the 1935 season was the Beach Club, a place to eat, drink, and dance. Located on the former site of the old boathouse, the building was charming, with its salmon-colored siding, shutters, window boxes, and neon-lit sign. Not long after the Beach Club was built, the corner was altered to accommodate Abbott's Frozen Custard stand. This stand later served frozen yogurt and also french fries.

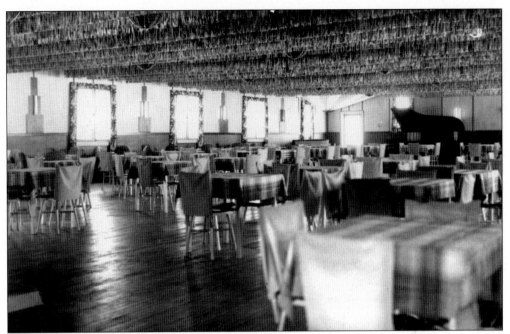

The interior of the Beach Club was decorated in a tiki theme. Notice the grand piano and the door that led to a sun porch overlooking Conneaut Lake.

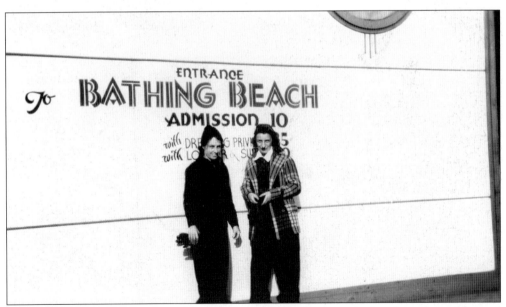

Conneaut Lake Park once charged an admission fee of 10¢ to use its beach, and an additional price to rent a bathing suit. The lower level of the beach club was used as the bathhouse for the beach. Betty DeVore (left) and Marjorie Rockwell posed in front of this sign on a day that their clothing suggests was too cold for swimming. (Marge Crossley Collection.)

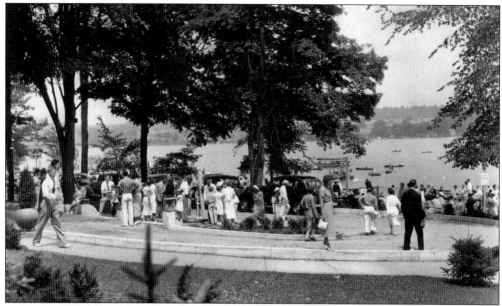

Before the days of jet skis and speedboats, the lake was much calmer, although equally beautiful. Cars still drove into the park alongside the boardwalk and up to the hotel, even after a fence was built around the park in 1990.

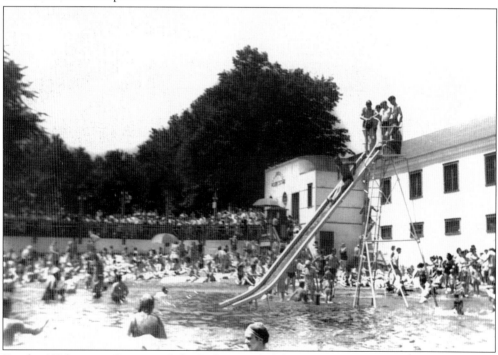

For the 1936 season, Conneaut Lake Park expanded the sandy beach and installed a 600-foot-long boardwalk, which spanned the lakefront from the Beach Club past Hotel Conneaut. Swimmers in this photograph are enjoying the sun and the water as much as they did during the Exposition Park years, only at this time, the bathing wear is much more revealing than that worn by the earlier swimmers.

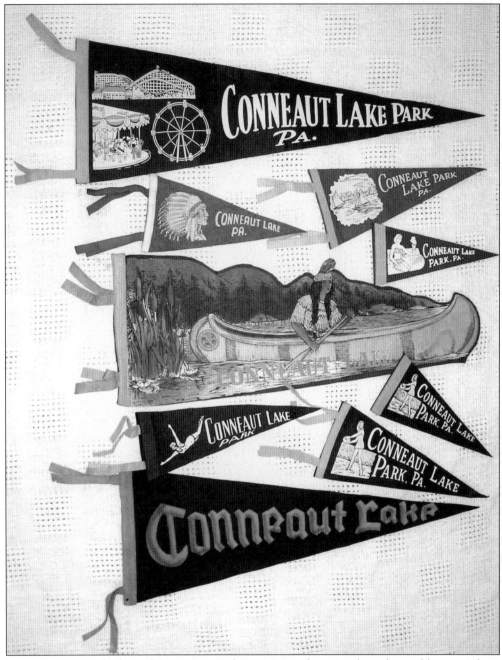

Since the very early days of Exposition Park, visitors to the resort have been able to purchase souvenir pennants. These felt pennants came in a variety of sizes, colors, and designs.

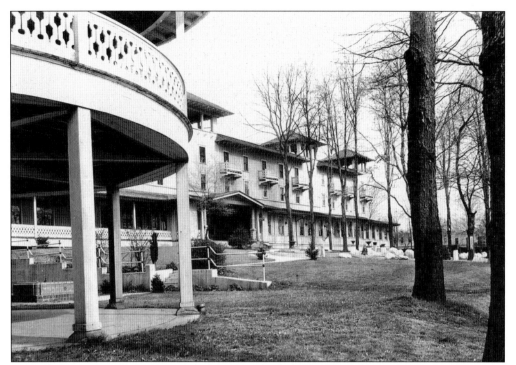

In the 1920s, a series of additions were constructed at Hotel Conneaut. The columns on the left support the veranda of the new south wing, which housed the new Crystal Ballroom, and newer, larger guest rooms, complete with private baths. In the background, the cement-block midway buildings are visible. At the time this photograph was taken, the hotel was still dormant for the winter.

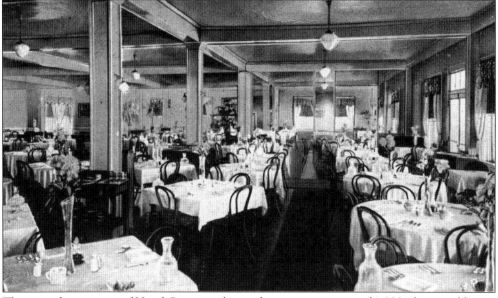

The main dining room of Hotel Conneaut boasted a seating capacity of 1,000 after an addition. Notice the mirrors on the back wall that were used to make the room appear even larger than it actually was.

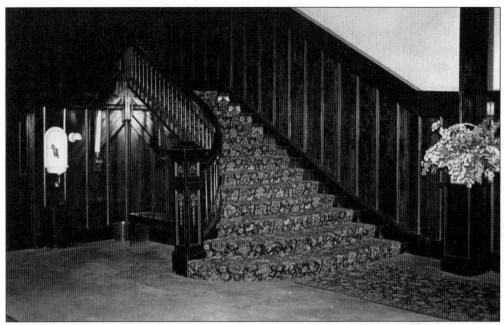

The lobby of Hotel Conneaut featured wicker furniture, a fireplace, wooden paneling, and this grand staircase. Notice the drinking fountain to the left of the stairs. Hotel Conneaut also had its own bakery, a nursery, a barbershop, and a souvenir stand.

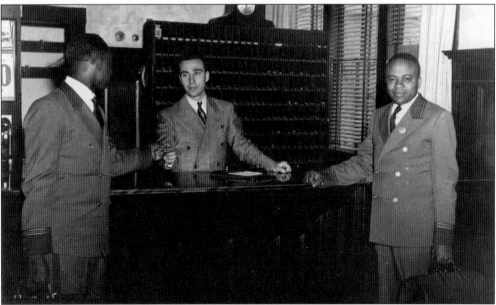

Two bellmen confer with the desk manager in this typical daily scene from the hotel lobby. However, the life of Hotel Conneaut was threatened when a fire broke out on April 28, 1943. The electrical fire began when a wire from the main switchboard burned through the wall into a guest room on the second floor of the hotel. That fire was put out, but the following day another fire was discovered by Conneaut Lake Park police chief Dud Fisher at about 3:45 a.m. Apparently, the fire originated in the smoldering remains from the night before. The lobby of the hotel, approximately 150 guest rooms, and the main dining room were lost in the blaze.

55

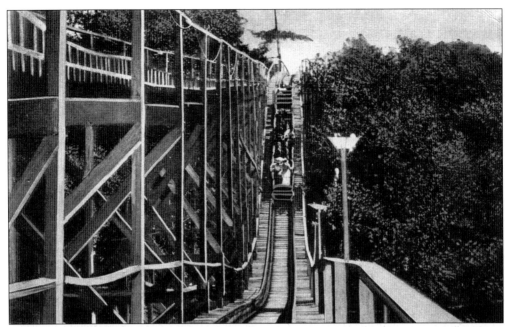

The design of the scenic railway—with its shallow drops and lackluster hills—became dated by the 1930s. At the end of the 1937 season, the scenic railway was either completely demolished or partially reused in the construction of the Blue Streak roller coaster.

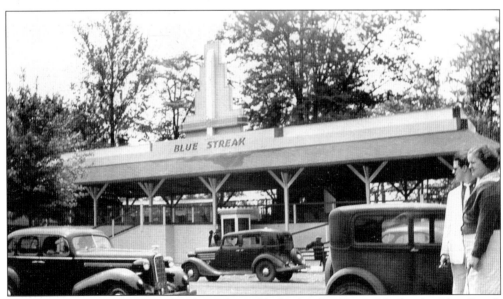

Built by Edward Vettle of Pittsburgh, and possibly his brother Erwin Vettle, the Blue Streak instantly became a landmark. It was built using the new technology of under-track safety wheels, which enabled the Blue Streak to have sensationally steep drops. The drops are still considered steep for modern-day roller coasters. This photograph was taken the first week the Blue Streak was open.

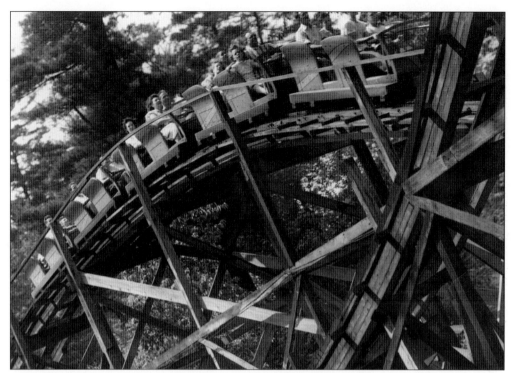

The Blue Streak trackage was built using what was known as a shallow-track design, named so because the coaster's track is split into upper and lower portions that are separated by cross supports, while most other coasters' tracks are simply constructed with a thicker track resting on top of the cross supports. There were blue streaks on the sides of the cars.

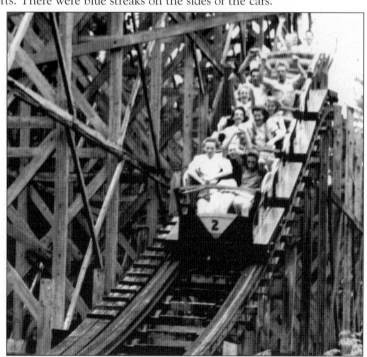

The Blue Streak quickly became Conneaut Lake Park's signature amusement ride. Its scenic journey through the woods helped make the coaster an even better riding experience. Notice that there are three people packed into one seat at the front of the train. State safety regulations would not permit such a thing in later years.

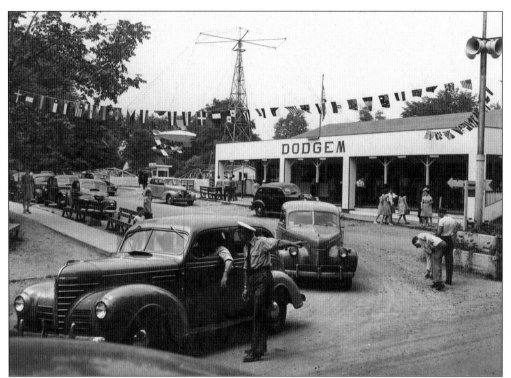

In the 1920s, the old Circle Swing was replaced on Park Avenue with a newer design by the Travers Engineering Company. In this newer incarnation of the Circle Swing, seaplane-shaped cars replaced the old wicker gondolas. These planes flew until they were replaced by even newer vehicles in 1949.

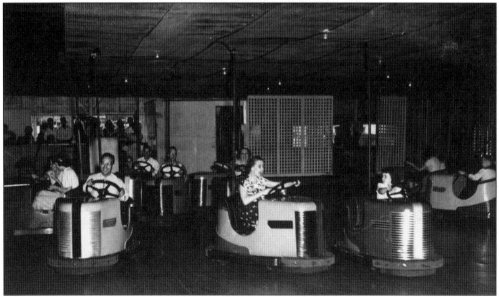

Since the 1920s, Conneaut Lake Park has had a Dodgem ride. In the 1930s, the ride burned down and was replaced with a more modern version in a new building that stood at the northwest corner of Park Avenue and Comstock Street, on the former site of the Park Hotel.

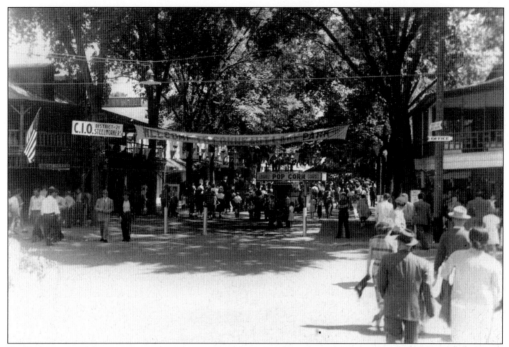

Park Avenue (the main midway) was bustling on the day this photograph was taken, as it usually was on large picnic days. This day, the CIO (Congress of Industrial Organizations) was having a picnic at the park. The CIO later merged with the AFL (American Federation of Labor). Notice the formal dress of the park guests.

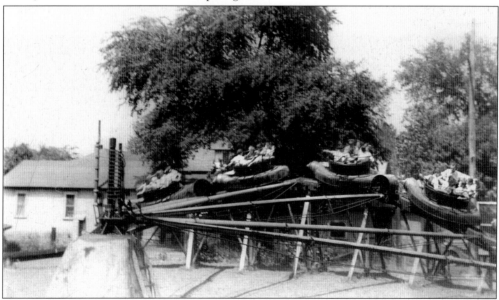

New for the 1925 season was the ride generically known as the Tumble Bug. Built by the Travers Engineering Company of Beaver Falls, this ride was once an off-the-shelf item that could be found in just about any amusement park during that era, but it has since become a rarity. Since this time, guests have expected to see this historic ride at Conneaut Lake Park and hear the familiar buzzing sound its motors produce.

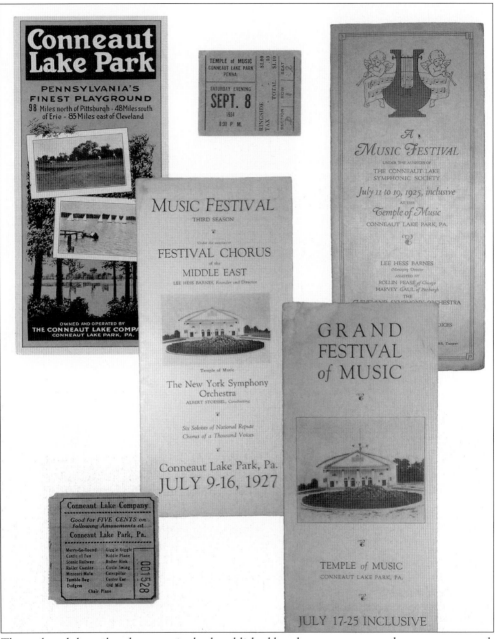

The park and the railroad companies both published brochures to promote the amusement park and resort located at the end the railroad line. During this time period, advertising materials were not as colorful as they had been in previous years. This was due in part to the resort's financial struggles during this time.

Three
Pennsylvania's Perfect Playground
1944–1973

This bathing beauty greeted visitors and lured them to the resort for many years. During this time period, management promoted Conneaut Lake Park as a well-rounded family-resort destination.

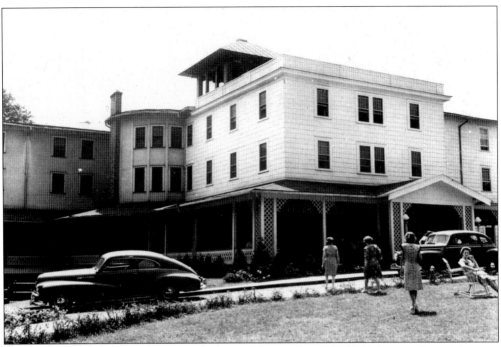

Because of the war effort during the 1940s, Conneaut Lake Park was not granted permission to rebuild the damaged part of the hotel after the fire. As a result, this "abbreviated" hotel structure was built. Although the hotel was much smaller after the fire, it still had much of the charm of the old, with its veranda, lawn, and lake views.

After the 1943 fire, a new lobby was needed in Hotel Conneaut to replace the original. As pictured here, the new lobby featured pinewood paneling and shiny linoleum flooring—materials that were certainly of the time period but were rather foreign in a Victorian hotel.

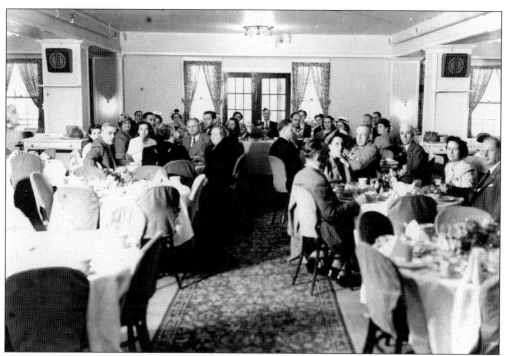

The main dining room was one of the casualties in the Hotel Conneaut fire. Thereafter, dining was moved to the lower level of the hotel (pictured), under the Crystal Ballroom. This move put dining closer to the lake and just steps from the boardwalk.

Park Golf, often listed in resort advertising material, was actually sold off in 1932 and after that time was privately owned. The resort's proprietors realized that even though they did not own the course, Park Golf could still be used to their advantage as another attraction to the area.

Because of its prime location on the lake, Conneaut Lake Park probably had one of the most beautiful views of any amusement park in the country. Notice the Oakland Hotel in the distance, a historic structure that was famous for its boat-shaped pier. The Oakland was not a Conneaut Lake Park hotel, but it was fondly remembered after its demolition in the 1960s. (Frank Miklos Collection.)

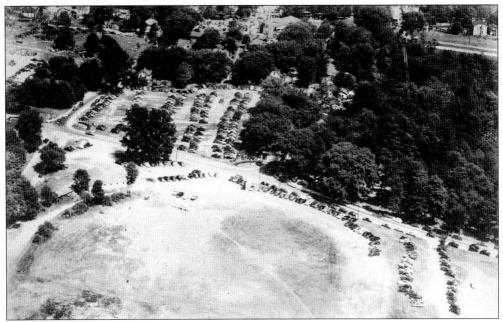

During the late 1940s, there were still visible traces of the old racetrack of the Exposition Park years. By this time, the resort had started making its transition from a railroad park into an automobile park, as evidenced by the large number of cars in this view.

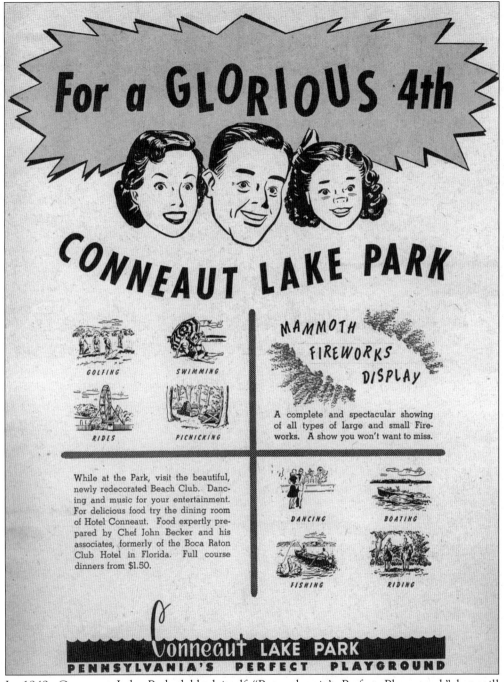

In 1949, Conneaut Lake Park dubbed itself "Pennsylvania's Perfect Playground," but still emphasized that it was a resort destination and not just an amusement park for day trips.

On the ground level of Dreamland Ballroom were concession stands selling candy, nuts, candy apples, taffy, and candy floss (cotton candy). By the 1950s, a roof had been added to the promenade on Dreamland Ballroom.

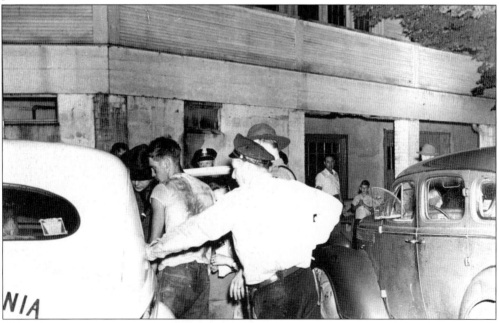

This photograph suggests that these teenagers did something that violated the family atmosphere of the resort, and as a result, they had been put in the park jail until state police could arrive to take them away. Located under Dreamland Ballroom, the resort jail was sometimes called the Fisher Hotel by park employees, named so after Dud Fisher, then the Conneaut Lake Park police chief.

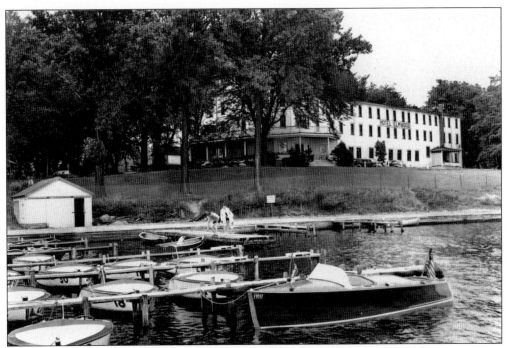

In 1967, management made the difficult decision to demolish the Hotel Elmwood, which simply needed too many repairs. At the time, the hotel needed a new porch and foundation, a new roof, a sprinkler system, and new plasterwork. Before demolition, furnishings were moved to Hotel Conneaut and the employee dormitories.

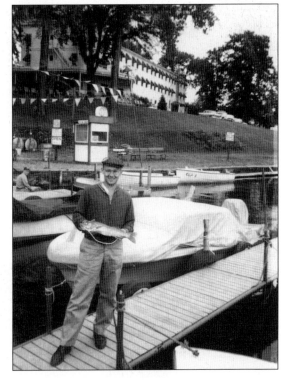

In 1962, Elmer Freeland, then owner of Conneaut Lake Park, sponsored a free-for-all family fishing contest. Frank Sunday, 27, pictured here, received $10 for landing his fish. Freeland told reporters that at the time this photograph was taken, $3,000 worth of fish were still swimming in the lake. Notice the little CLP putter boats that were available for hire.

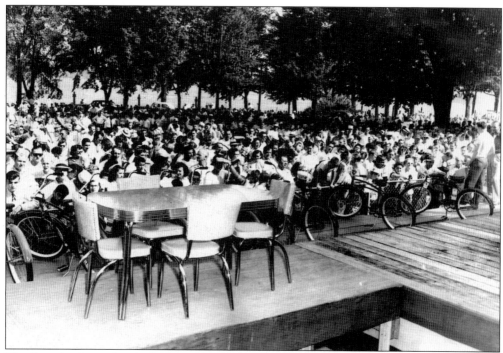

The Free Act Lawn has been a center of park activities since the very early days of the resort. Contests, shows, concerts, and other activities were held on this lawn quite frequently. Here, some sort of contest or promotion for a brand-new kitchen table is in progress.

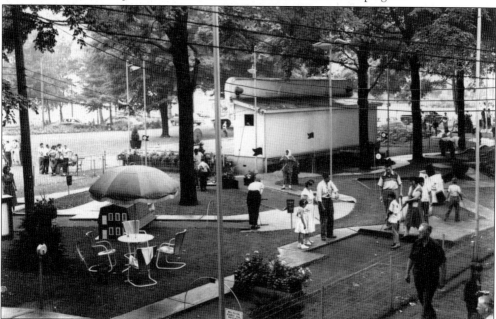

New for the 1941 season was this mini-golf course, located in the middle of Center Street, on the former site of the Sunken Gardens, between the Free Act Stage and bowling alley building. The original Tom Thumb Mini Golf, located at the northwest corner of Reed Avenue and Lake Street, closed at the end of the 1940 season.

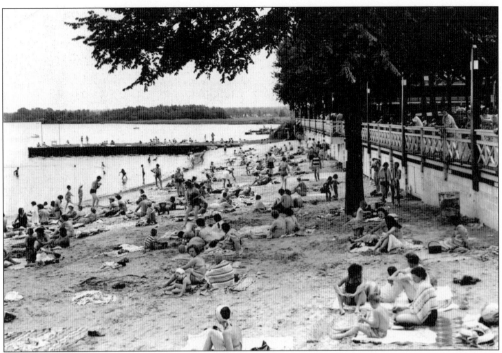

Although the beach has not changed much since it was conceived in the 1930s, it has been the site of many changes in bathing suit fashions through the decades.

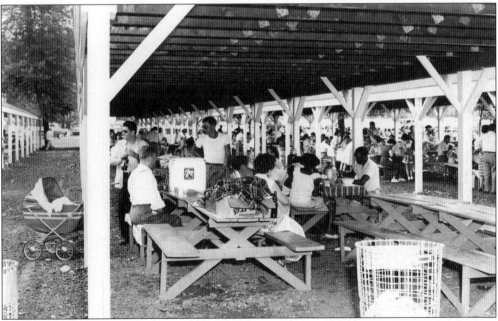

Were it not for the picnic grounds, Conneaut Lake Park would not exist today. Thousands crammed into these shady groves annually and helped keep the resort afloat. Today, these groves are used for the same purposes. The unusually long and slender Reed Avenue picnic shelters, with their armies of wooden picnic tables, have been the venue for many company picnics and family outings over the years.

In 1961, the old bowling alley was converted into the fun house. In later years, this building housed the Ultimate Trip ride. The fake cow in front of the bowling alley was being used for a special contest this day.

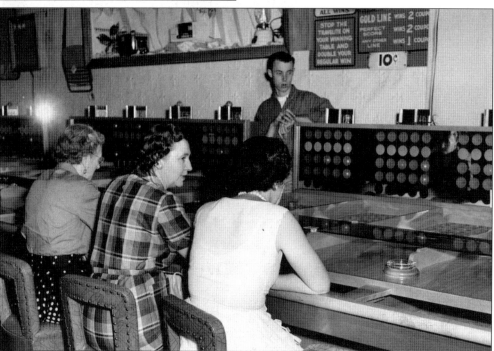

Fascination was a game developed in the 1950s for an entire room of people to play at once. It was an electronic bingo game of sorts, with a ball that a player rolled across the table, under some glass, over a bump, and onto the game card. The ball could fall into any number of holes arranged in a grid. In front of each contestant was a display of lights that corresponded with the different holes in the grid. After the ball fell into a hole, a bulb would light up on the display. When a player lit a row of lights, four corners, or all lights, the individual would receive a Fascination ticket to redeem for a prize.

High Striker has long been a staple amusement park game. This game was located on Center Street between Dreamland Ballroom and the Midway Buildings. During dances, some of the park brats would hang out on the Dreamland Ballroom promenade, where they would heckle people who were playing High Striker.

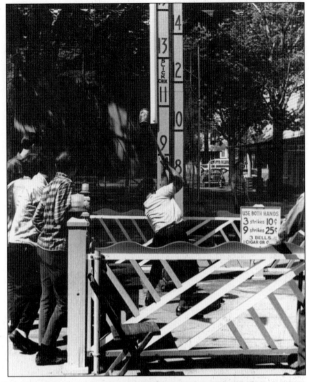

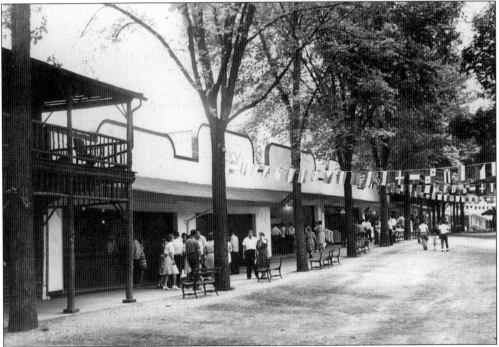

Many of the older, storefront-type separate buildings on the midway were replaced in the 1930s by a single new building that better suited an amusement park. The new structure housed game stands and a dark ride.

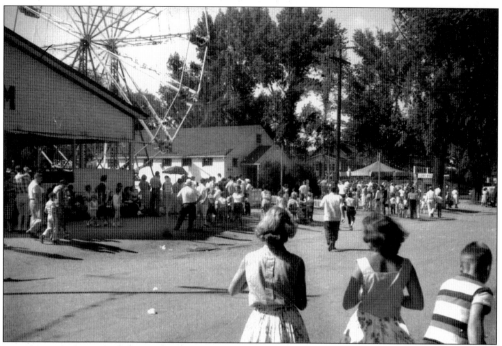

For about 30 years, the Ferris wheel was located behind the Dodgem building. This ride was a 16-car version that remained at the park until 1990. (Frank Miklos Collection.)

The Pretzel, advertised as a "Laff in the Dark" ride, was a fun-house type of attraction. The building originally housed the Old Mill ride, which featured long wooden canals along which wooden boats would navigate, occasionally passing by scenes, or grottos, as they were called. The Pretzel had electric-powered cars, with pretzel-shaped weights in the front of them to maintain balance. The ride was retired in the 1960s.

In 1949, the Circle Swing changed yet again. The tower was covered in stainless-steel sheets, and the seaplanes were replaced by shiny, stainless-steel, Buck Rogers–esque rockets. The ride was fittingly renamed the Rockets.

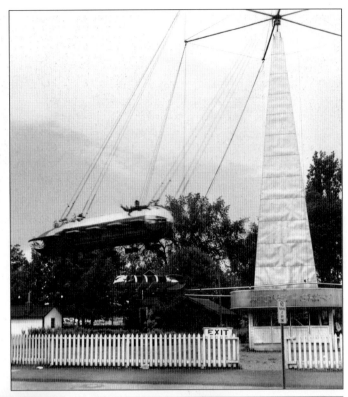

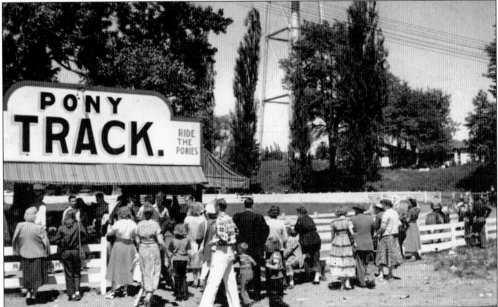

Conneaut Lake Park's first pony track opened in the 1920s. When this photograph was taken, the Pony Track was located on the former site of the Chute the Chute pond, with the station built on the former location of the original trolley station. Here, children were able to ride ponies while a parent or a park employee walked with them around the track. The pony track remained at this spot until 1950. (Katie Hilton Collection.)

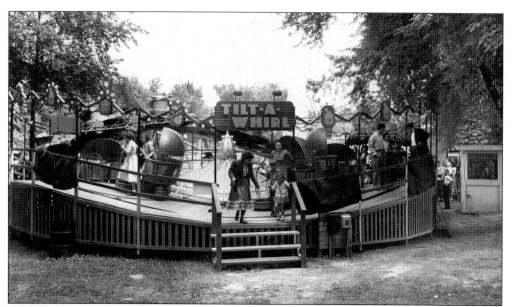

In 1949, Conneaut Lake Park purchased its Tilt-A-Whirl, a ride that almost every park has had at one time or another. Built by the Selner Manufacturing Company, the Tilt-A-Whirl has been almost as common as the Ferris wheel, carousel, or roller coaster.

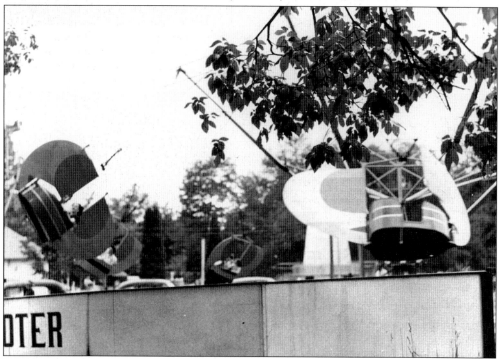

Conneaut Lake Park's first Flying Scooter ride was an eight-tub model that was located on the grassy area behind the Dodgem building. Older children and younger teens, in particular, liked the ride most because their smaller body weight, coupled with practice, allowed them to become skillful at snapping the cables as the ride spun. The cables did not actually break, but instead would go limp and suddenly tighten, producing the sound of a cracked whip.

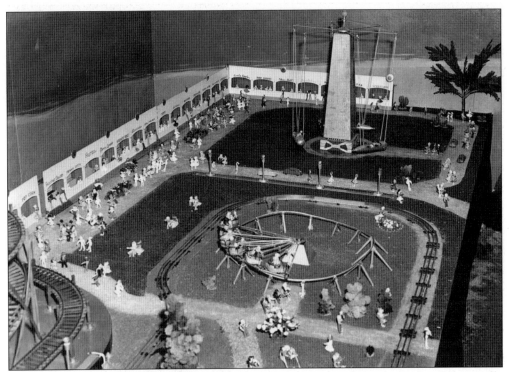

For a few years, a miniature model of the park operated in a booth on the midway. Eventually the model was moved into the miniature train tunnel, where it would sit idle until the train pulled into the tunnel and triggered the model's operation. As the miniature rides were in motion, a recording would play the sounds of a full-scale amusement park.

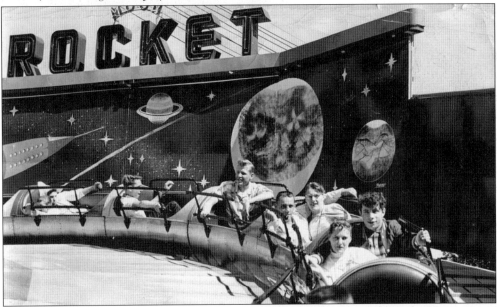

The Moon Rocket was a ride similar to the modern Bayern Kurve bobsled ride. Instead of bobsleds, however, two trains of rocket cars stretched around the entire ride's course. The ride was inspired by government space exploration at the time.

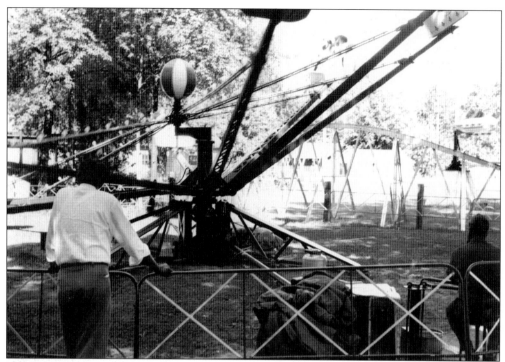

Holding 16 passengers in eight cars or tubs, the Octopus was a ride similar to today's Spider ride. Both rides were built by the Eyerly Aircraft Company, although this one was built during the 1940s.

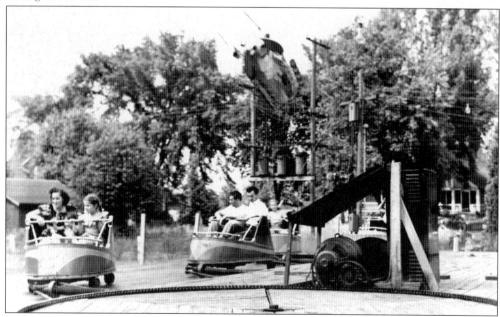

In the 1940s, Conneaut Lake Park purchased its first Whip, built by W. F. Mangles of Coney Island, New York. The Whip was an oval-shaped ride that spun 10 cars around a central platform. When the cars reached the end of the platform, riders would feel a whip-like sensation as their car zipped around the turn.

After the Blue Streak's initial drop, riders experienced this rather strange flat section of track before ascending the second hill.

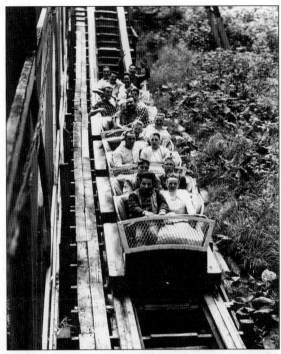

In 1962, a coaster marathon to raise money for Camp Lend-A-Hand was held by disc jockeys Brian Emory of Greenville (seated left) and Dick Lepley of Meadville (seated right). The 283 trips during the marathon also smashed the previous world record by 22 trips. Here, the riders take a break to enjoy refreshments served by Mrs. Shadley (left), wife of the park's public-relations manager. The marathon lasted for 14 hours and 15 minutes and raised $904.05.

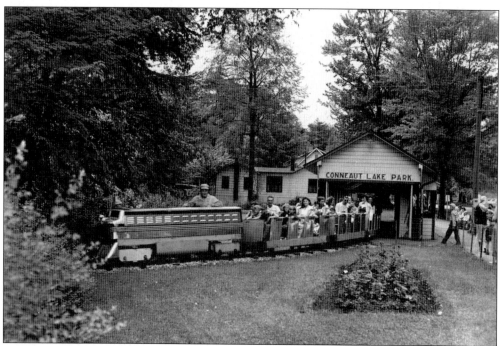

On big picnic days, two trains were needed on the miniature railroad to double the ride's capacity. George Ream, an inhabitant of the park, was well known for being the operator of the miniature train. Occasionally he would give some of the kids who lived in the park a chance to sit with him in the miniature locomotive.

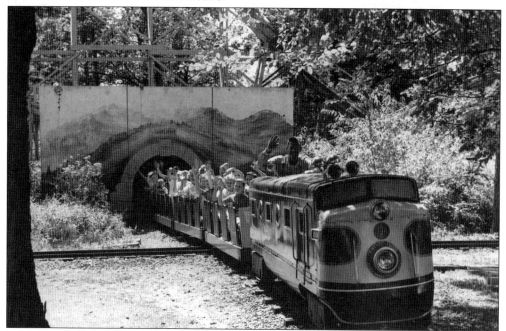

Notice how much the train cars resemble roller coaster cars. The National Amusement Device Company, the firm that built these trains, actually manufactured two new trains for the Blue Streak in the 1960s.

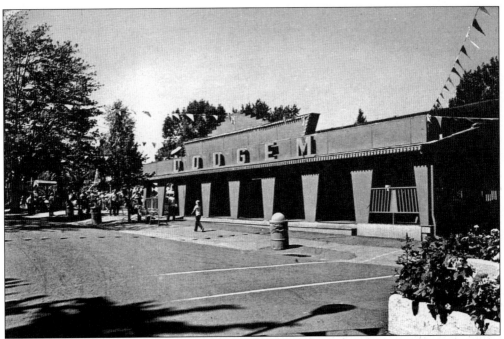

The old Dodgem building received a facelift in the 1960s. This change spiced up the exterior of the building, which had been rather basic looking previous to remodeling.

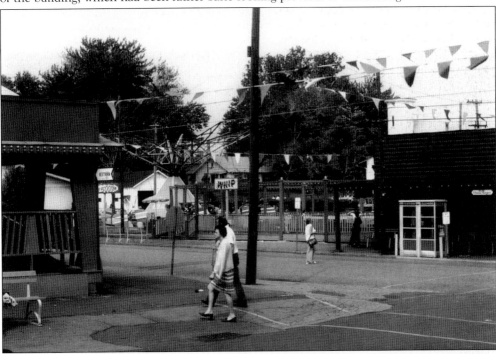

In the 1960s, a new 10-car Flying Scooter was purchased to replace the original 8-car version. The new ride was installed across the street from the old one, on the southeast corner of Reed Avenue and Comstock Street. The Flying Scooter remained a favorite until it was retired at the end of the 1980 season. The nearby Whip stood at this location until it was sold in a 1992 auction.

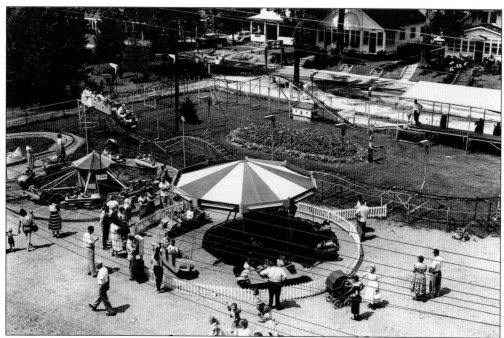

In the late 1950s, Conneaut Lake Park offered a great selection of miniature rides for the small fry. Before this time, amusement parks had been more adult-oriented, but when America experienced its great baby boom, park operators knew they had to adapt to turn this demographic change into an opportunity. Notice the lack of restraining fences to keep people from getting too close to the operating rides.

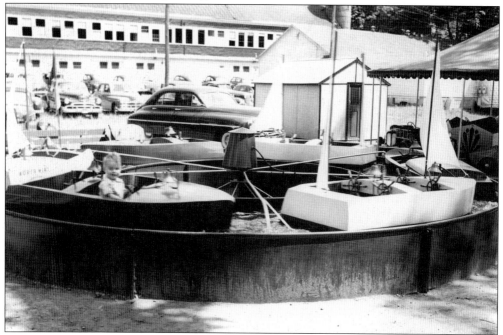

This rug rat had the whole ride to himself. It must have been a tough job operating a boat that normally required four riders to man all four steering wheels.

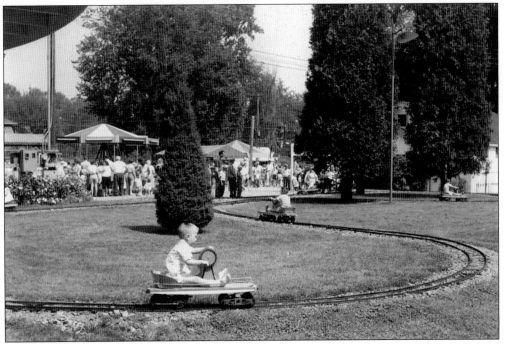

The Hodges Handcars were a favorite in Kiddieland, although they were removed and stored behind the scenes in the then-new fun house, built in the old bowling alley. When Kiddieland was moved in 1963, the ride was never reinstalled.

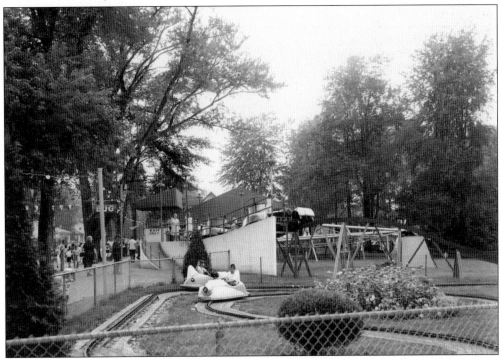

The Turnpike Cruisers were fortunate enough to make the move to the new Kiddieland in 1963. Their space-age design made them appear ready to blast off into space.

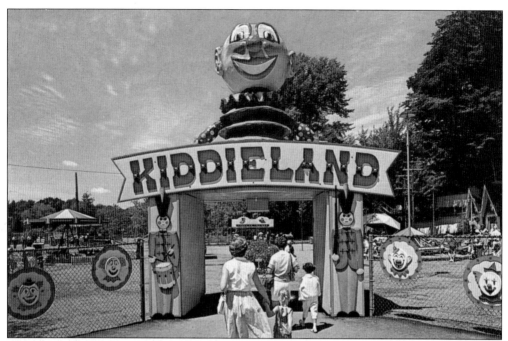

The new Kiddieland, located on the former site of the old train depot, featured this jack-in-the-box entrance. The oversized head bobbled and welcomed fun-seeking children who were not allowed admission to the miniature rides' full-sized counterparts in the park.

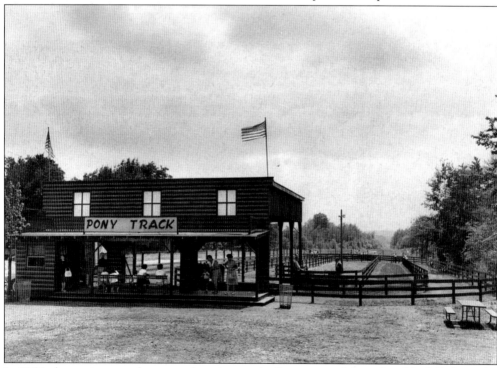

In 1950, the ponies moved to a new location on the former site of the railroad bed. Perhaps the ponies felt more at home when Kiddieland moved to this area as well.

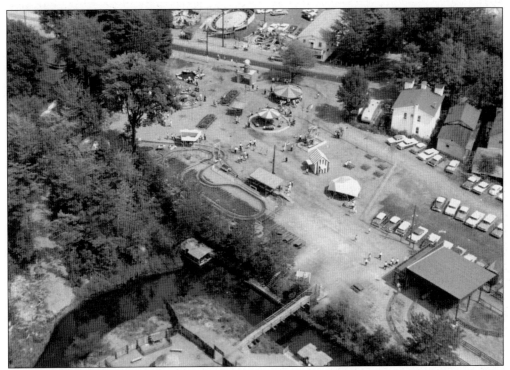

The remains of the old railroad bed were still visible underneath the Little Dipper kiddie coaster when Kiddieland moved to its new location. The river at the bottom of this photograph was an attraction known as the Jungle Cruise.

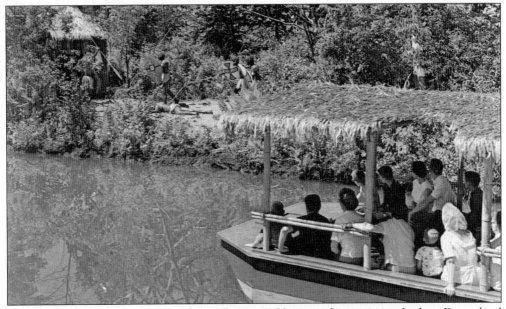

The Jungle Cruise was an attraction largely inspired by a similar attraction built at Disneyland in Anaheim, California. This attraction simulated a safari through the jungle on a flat-bottomed boat. Riders would encounter wild animals and natives on the banks of its channels. (Katie Hilton Collection.)

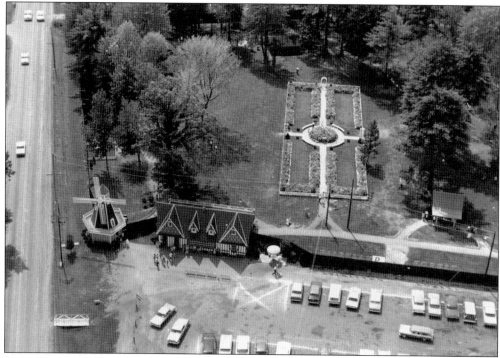

In 1960, a wooded section across the road from the park was turned into Fairyland Forest, a separate attraction, where guests could pet live animals and visit scenes and characters from Mother Goose stories.

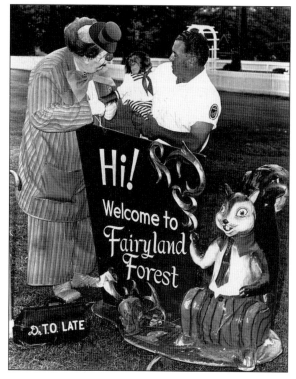

The welcome sign was a familiar sight at Fairyland Forest, and also a popular spot for photographs. Pictured here in 1968 are park clown Bobby Baxter, little Miss Connie at age seven months, and Fairyland Forest zookeeper Bernie Hohl.

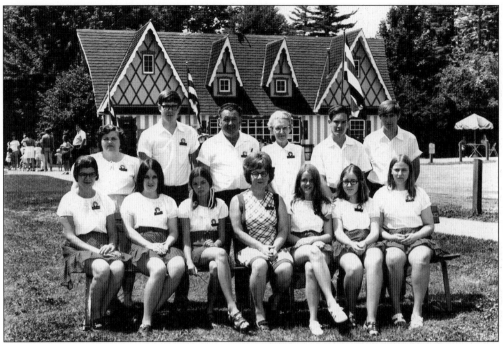

Conneaut Lake Park was a great place for high school and college students to work during the summer months. Here, the Fairyland Forest employees pose for a staff photograph in 1971. Bernie Hohl (standing, third from left) and Jane Hohl (seated, fourth from left) managed the attraction during its entire existence.

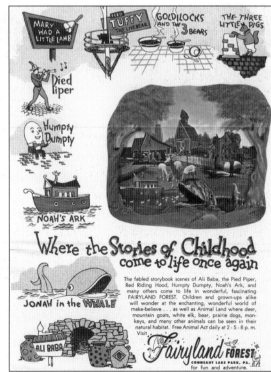

An early promotional brochure from Fairyland Forest shows the scenes that brought fairy tales to life for children. (David and Nancy Manning Collection.)

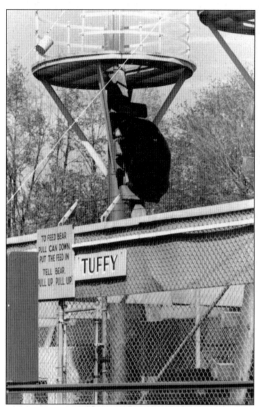

Tuffy was one of two brown bears that called Conneaut Lake Park home. In Fairyland Forest, Tuffy would perform daily. During the off-season, the bears would hibernate in manmade caves dug into the hillside next to the Convention Hall. (Carol West Collection.)

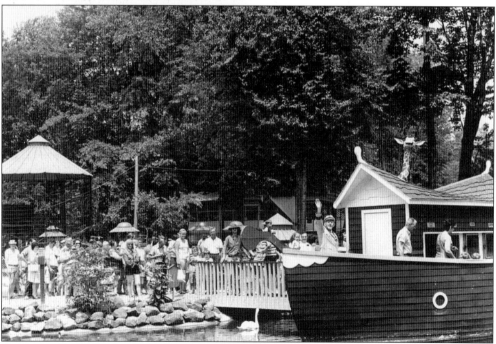

Noah's Ark was an attraction at Fairyland Forest that had live animals on board. The monkey cage is seen at left, behind the long line to get onto Noah's Ark.

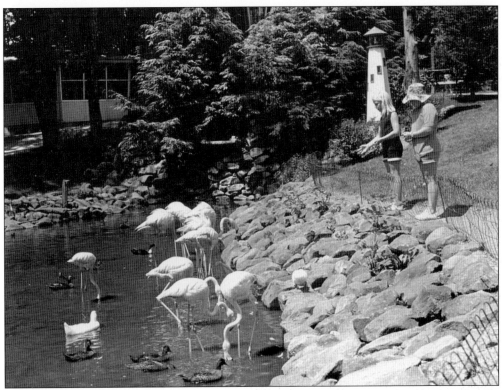

The pink flamingos were featured in another live-animal attraction. Due to their artificially created environment, the flamingos were fed a special nutrient (not native to Western Pennsylvania) to maintain their vibrant color.

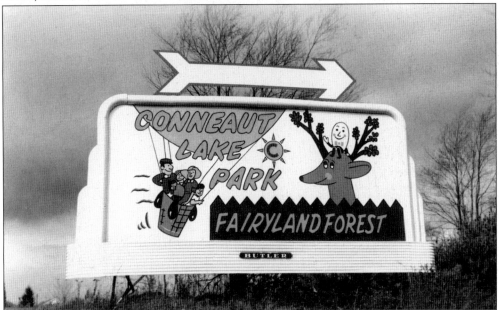

Fairyland Forest remained a popular attraction until it was closed at the end of the 1985 season. The property was turned into a campground.

In 1964, Conneaut Lake Park opened its brand-new convention hall. Nothing more than a steel frame covered with an aluminum skin, it had a hard time fitting in with the rest of the resort's other, more historic structures. Located on the former site of the pony track, the convention hall offered a spacious facility for conventions, large picnics, and even sporting events. The convention hall also housed dismantled rides during the winter months.

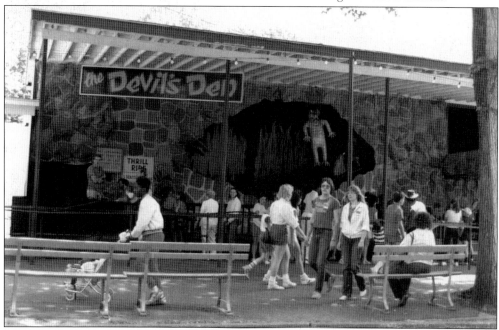

The Devil's Den was a gravity-powered dark ride built in 1968 by the Pretzel Amusement Company. Whereas the park's original pretzel ride had motorized vehicles, this ride featured a small, coaster-like chain lift that allowed the cars to navigate a downward-sloping course. (David Hahner Collection.)

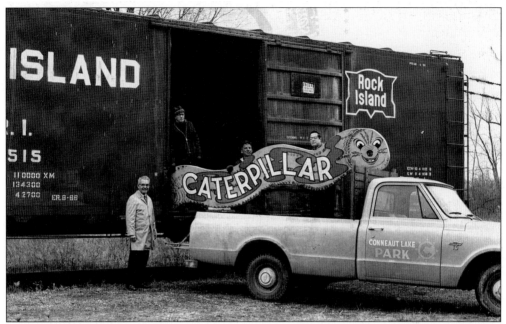

In 1968 a new Caterpillar ride was purchased. This model was built by the Alan Herschell Company, and was delivered via the Rock Island Express line on railroad tracks that still went into the resort.

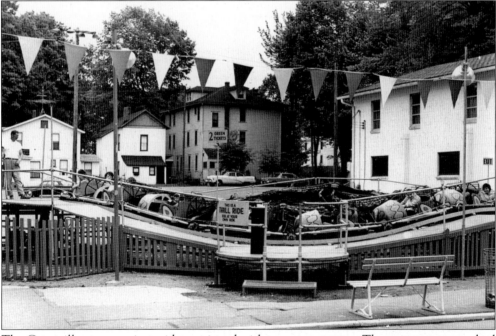

The Caterpillar was a unique ride, equipped with a canvas canopy. The canvas was attached to springs that would hold the canopy open. When the ride started, centrifugal force would pull the canvas over the riders, causing the ride to look like a caterpillar. Conneaut Lake Park had a Caterpillar from the mid-1920s until the 1970s, when high maintenance costs precipitated its removal.

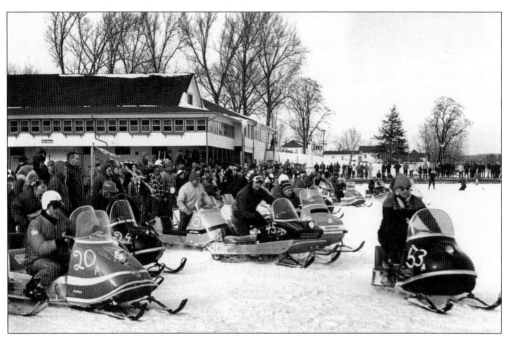

During the winter, snowmobile races were held on the frozen lake. The Northwest Regional Snowmobile Finals were sponsored by the Conneaut Lake Chamber of Commerce. This photograph was taken on Sunday, March 3, 1968, the only year these races were held at Conneaut Lake Park. (Donna Hays Collection.)

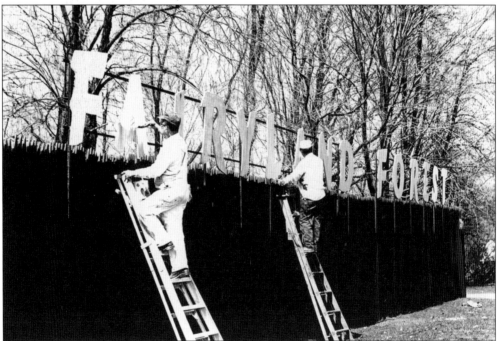

The winter and spring months provided opportune time to refurbish, renovate, and restore anything that needed it. As a result, the resort always looked new and freshly painted when it opened in the spring.

During the off-season, the maintenance department was hard at work refurbishing rides in preparation for the next year. In this photograph, Bill Rutter (left) tends to the Ferris wheel while Red Glasgow, head of maintenance, inspects.

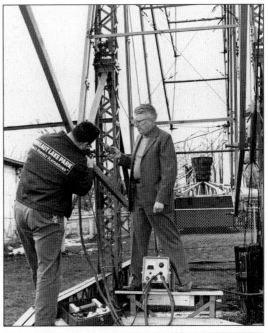

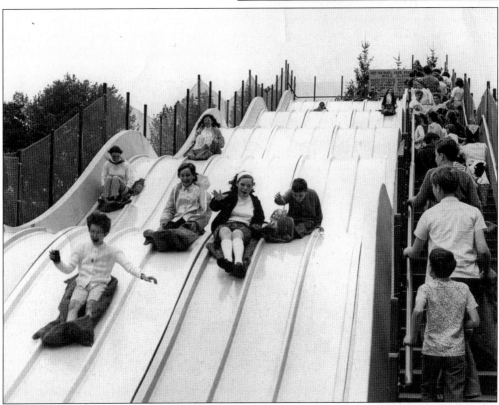

The fiberglass Astro Slide, new in 1969, was probably one of the maintenance department's favorites, because it required little if any maintenance at all. Riders experienced occasional friction burns if they were not careful.

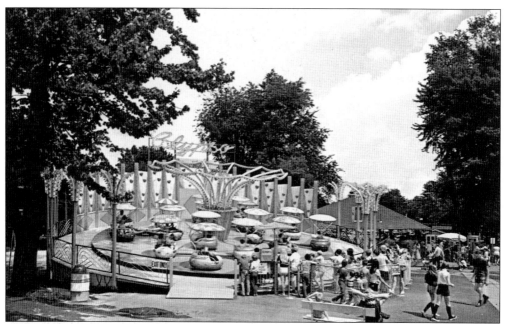

Park employees sometimes referred to the Calypso as the "Collapso" because of its numerous mechanical problems and many hours of subsequent down time. Installed in 1972, the Calypso was removed in 1980.

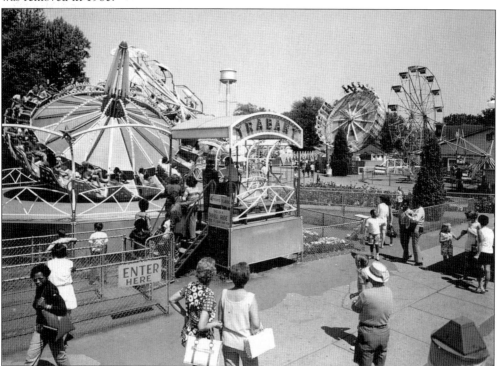

This is an excellent view of a high-energy section of the park, packed with rides. Visible are the Trabant, Paratrooper, Round-Up, Ferris wheel, and Scrambler. Also noteworthy is the water tower in the background, overlooking the park activities.

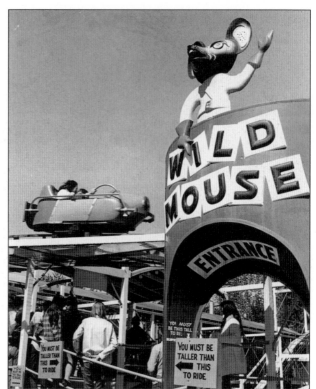

In 1961 Conneaut Lake Park installed the Wild Mouse, a small roller coaster known for its sudden and sharp turns that made its riders feel as though the cars were about fly off the track. This rodent was exterminated at the end of the 1990 season.

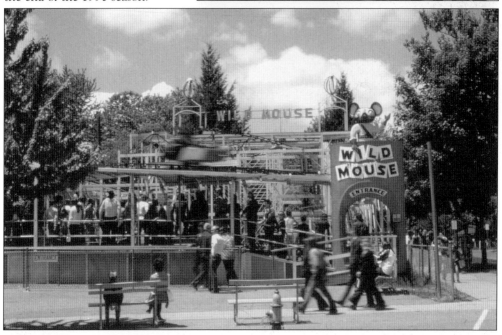

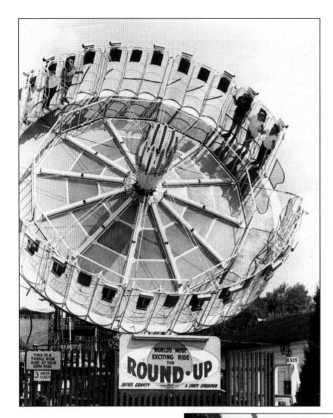

In 1966, the Round-Up was installed behind the Comstock Street restrooms. The ride was similar in construction to the Paratrooper and was built by the same manufacturer, Frank Hrubetz and Company.

In the mid-1960s, two new trains, dubbed Century Flyers, were purchased for the Blue Streak from the National Amusement Device Company. These sleek, stainless steel–covered trains featured working headlights powered by a battery mounted in the side of the head train. The center headlight, known as a Mars headlight, would slowly revolve as it lit the coaster's course.

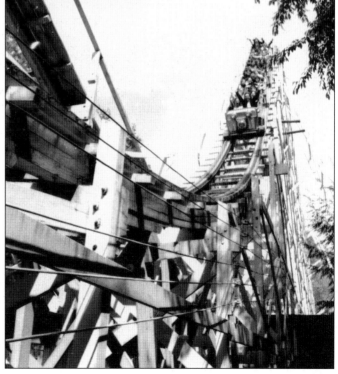

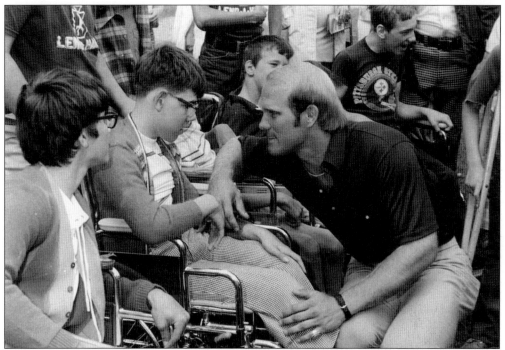
During the "Steel Curtain" era, Terry Bradshaw Day was held at Conneaut Lake Park. Pictured here with the Pittsburgh Steelers' quarterback are students from Camp Lend-A-Hand, a group that spent a lot of time at the park. This photograph was taken on July 11, 1973, the same day Conneaut Lake Park presented Bradshaw with an award.

The youngsters on this bench are enjoying candy floss and snow cones on the midway in 1972. Notice the quirky heads on the front of the fun house in the background of this photograph.

This 1969 Hotel Conneaut brochure advertised a newly renovated hotel. It was during this time that some peculiar color schemes and decorating materials were installed in the hotel.

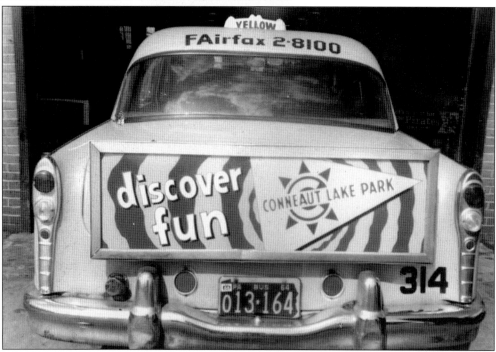

In the latter half of the 20th century, Conneaut Lake Park advertised heavily within a radius of nearly 125 miles from the resort. This taxicab in Pittsburgh displays the park's slogan in 1965: "Discover Fun."

Four
THE FLYNN ERA
1974–1992

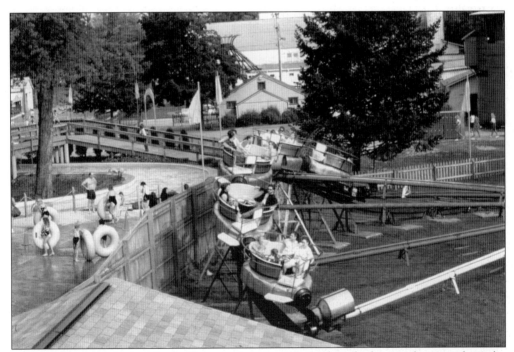

This era was a rough time for family-owned amusement parks, which were dropping from the landscape like flies. Charles Flynn, owner of Conneaut Lake Park, worked to blend old with new in an effort to stay competitive. (Jon Horning Collection.)

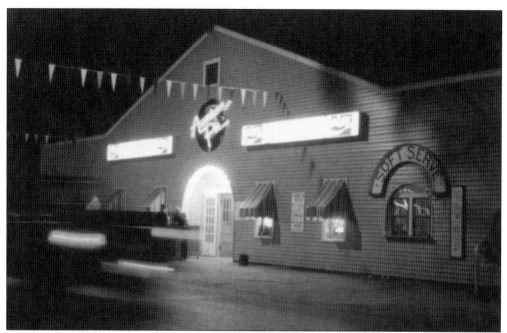

For a brief time during the 1980s, the Beach Club was known as the American Pie, complete with 1950s decor. When management auctioned away most of the park in 1992, much of the memorabilia was auctioned off as well. The following year this historic structure was renamed the Beach Club.

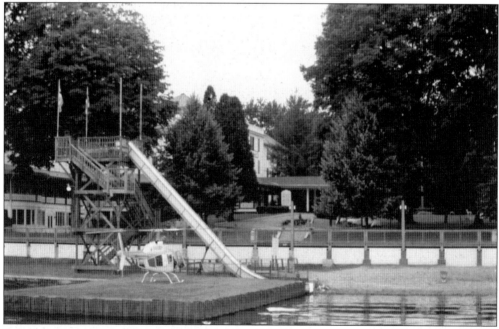

Rampage was a water slide constructed on the old Hotel Conneaut pier. The attraction was memorable because of its construction. Riders would carry heavy plastic sleds to the top of the structure, where they would sit until the operator pushed a button that caused the floor to tilt, which in turn, permitted sliders to take the plunge. (Jon Horning Collection.)

In 1986, management constructed a new water slide on the former site of the Astro Slide. Named Cliffhanger Falls, the attraction featured two 415-foot-long water slides attached to a 48-foot-tall tower. The nearby Dracula's Cave dark ride was gutted and its building was converted into restrooms, changing rooms, and locker rooms.

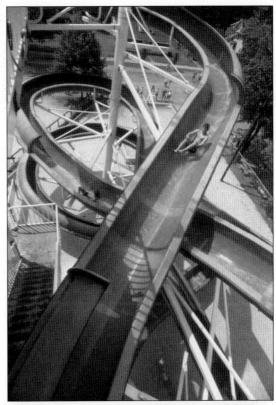

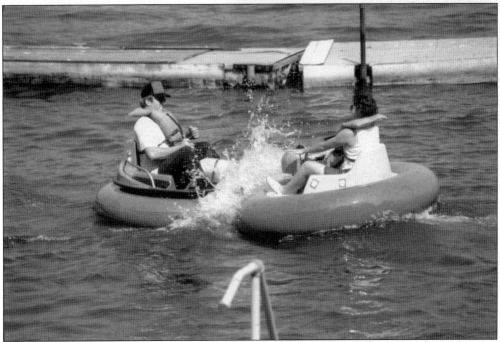

Battlin' Bob's Bumper Boats was another attraction that made use of one of the resort's greatest resources, Conneaut Lake. This attraction lasted through the 1980s.

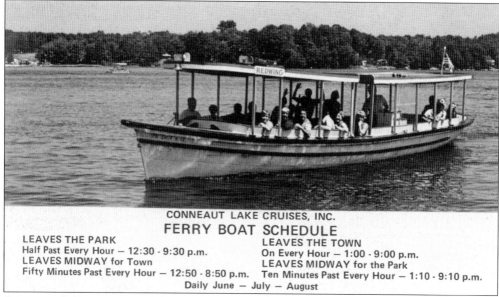

CONNEAUT LAKE CRUISES, INC.
FERRY BOAT SCHEDULE

LEAVES THE PARK	LEAVES THE TOWN
Half Past Every Hour — 12:30 - 9:30 p.m.	On Every Hour — 1:00 - 9:00 p.m.
LEAVES MIDWAY for Town	LEAVES MIDWAY for the Park
Fifty Minutes Past Every Hour — 12:50 - 8:50 p.m.	Ten Minutes Past Every Hour — 1:10 - 9:10 p.m.

Daily June — July — August

Conneaut Lake was one of the few lakes that had boats dating from the early 1900s still operating into the 1980s. Both the *Outing* and *Redwing*, built in 1927 and modeled after an earlier boat, operated on the lake until 1985. These were also the last dock-to-dock ferries in service on Conneaut Lake. (Katie Hilton Collection.)

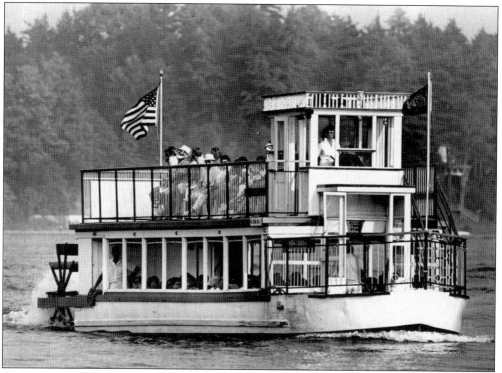

In 1973, Lloyd Holland, president and owner of Conneaut Lake Cruises, purchased this paddlewheel boat, moved it to Conneaut Lake, and named it the *Barbara J.*, after his wife. Sightseeing tours of the lake continued until 2001, when the *Barbara J.* was retired.

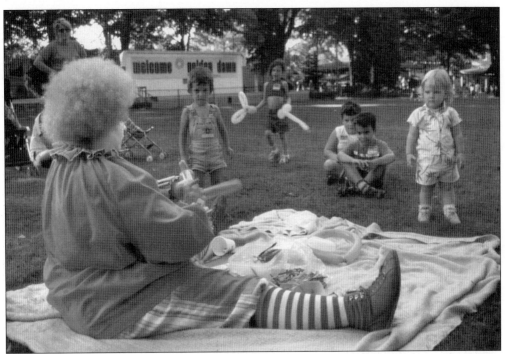

Mouse the Clown, played by the late Pauline Mandish, appeared at Conneaut Lake Park for many years. Mandish lived in a cottage in the park. Kiddieland was dedicated to Mouse the Clown in 1999, just before she died.

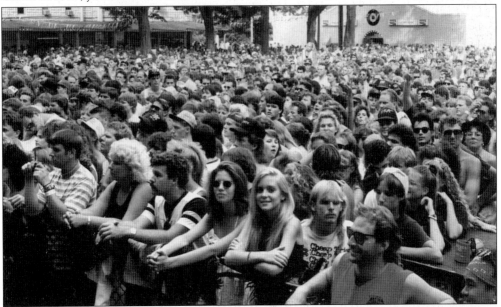

During the late 1980s, the Free Act Lawn hosted some big-name bands. Because it was becoming harder to compete with parks that were adding multimillion-dollar attractions, and insurance costs were rising, Conneaut Lake Park looked at other ways to keep people coming to the resort. Unfortunately, some unusually rainy summers had a negative impact on attendance at these concerts.

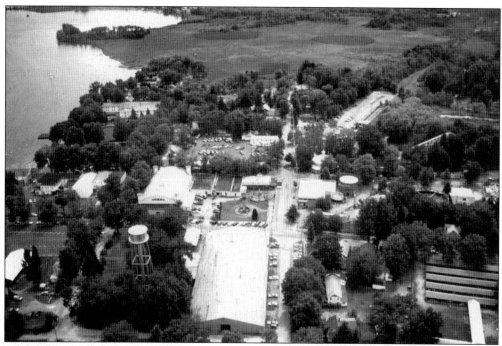

During the 1980s, the personality of Conneaut Lake Park was very much as it had been since the beginning. Although rides have continued to change over the course of nearly a century, the resort's tree-lined midways and old-time architecture remained unchanged.

Skee-Ball is a game similar to bowling, except it is played on an incline lane and contestants attempt to get the baseball-sized wooden balls to fall into holes rather than knock down pins. This game has long been one of the most popular arcade redemption games at many amusement parks.

The Blue Streak grove has for many years been the site of picnics and gatherings, with the Blue Streak serving as its backdrop.

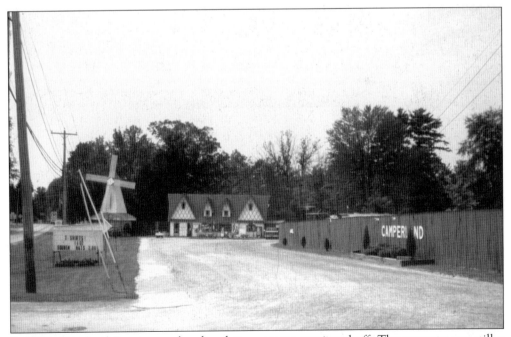

In 1985, Fairyland Forest was closed and its contents auctioned off. The property was still a natural, tree-filled setting, and it was subsequently converted into a campground known as Camperland. This change was a throwback to the earlier time when the resort side of the business was more emphasized.

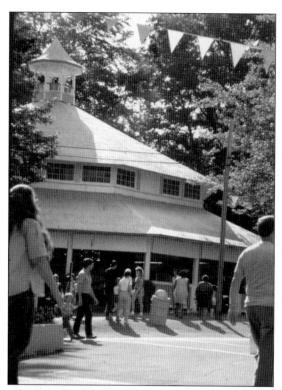

In the 1980s, the carousel remained as a strong reminder of the old days of Exposition Park. This 1910 structure has remained virtually unchanged since the day it was built.

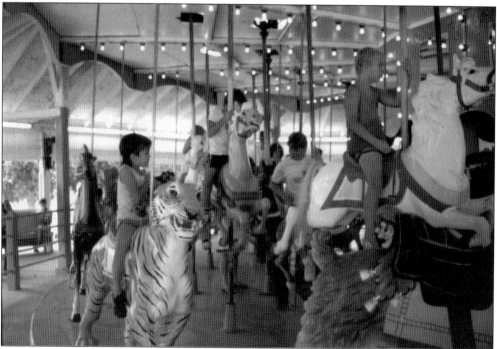

When this photograph was taken in the 1980s, many of the original carved wooden figures were still on the carousel. Also evident in this photograph is the drop ceiling that was attached to the frame of the ride when it was given a facelift in 1965.

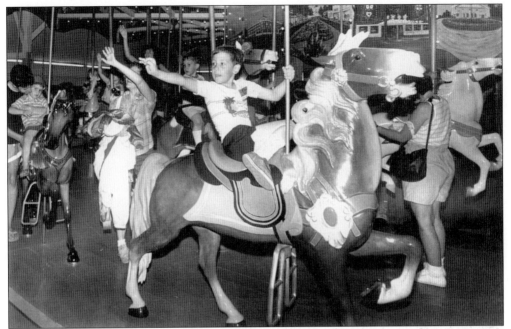

In 1989, the carousel received a complete renovation. In this project, many of the original carved horses were replaced with newer replicas—some also carved from wood and some made of fiberglass. Because the park needed money to expand the new water park and did not want to completely replace the old carousel, auctioning off the old horses seemed like the best compromise. Also in this project, early scenes of Exposition Park were painted on the inner running boards of the ride.

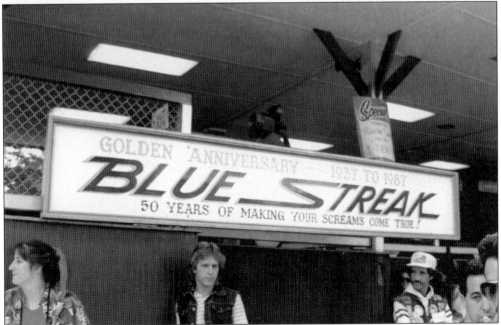

In 1987, the Blue Streak marked its 50th anniversary. To celebrate, the park threw a party and served birthday cake to Blue Streak fans. (David Hahner Collection.)

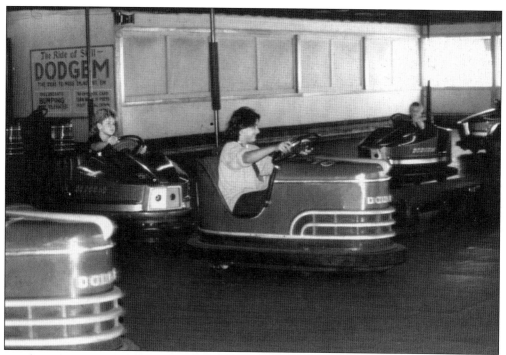

On this ride of skill known as the Dodgem, the idea was to "miss 'em not hit 'em." These cars remained in operation until they were replaced in 2001 with bumper cars, which have much softer, and safer, bumpers.

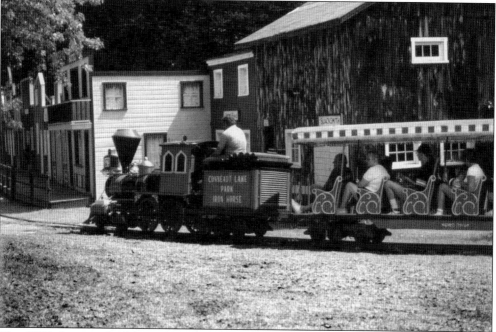

This 1987 photograph of the miniature train that was introduced in 1968 offers a glimpse of the old Western-themed buildings that replaced the former miniature train loading station. This newer, although older-looking train ride featured a Western-themed miniature town.

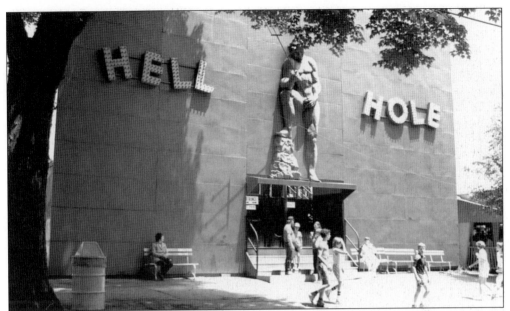

In 1976, the park purchased and installed a used Rotor ride that was renamed the Hell Hole. The pitchfork-armed devil on the front added some ballyhoo to the attraction. (David Hahner Collection.)

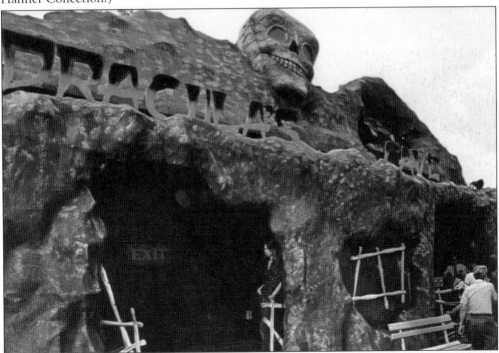

Originally opened as the Pit of Death in 1973 in the old Cuddle Up building, this fun-house attraction added a new indoor ride to the park. Although dark rides are great for rainy days, they have been disappearing from the amusement park scene due in part to high insurance costs. This attraction was renamed Dracula's Cave, apparently to be more family orientated. (Jon Horning Collection.)

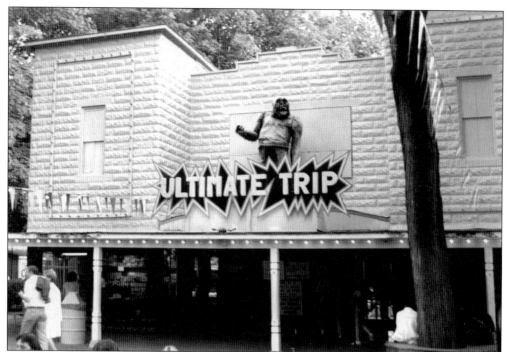

In 1976, the interior of the old fun house was completely torn out and the Scrambler was moved inside. The attraction was named the Ultimate Trip and featured black lights, strobe lights, and loud rock music. Since the width of the ride was greater than the width of the building, the right side of the structure was enlarged to accommodate it. (David Hahner Collection.)

In 1981, the old Flying Scooter ride was replaced with a new swing ride called the YoYo. The ride had hydraulically powered arms that lifted the swings off the ground as the ride spun. Once the arms reached their maximum height, the whole spinning section of the ride would tilt for a swooping sensation.

Replacing the Skywheel (double Ferris wheel) in 1984, the Sea Dragon had one of the best locations of any of the rides. The position of this big rocking boat offered an interesting view from the lake, and an even better view at night when it was lit up. (Jon Horning Collection.)

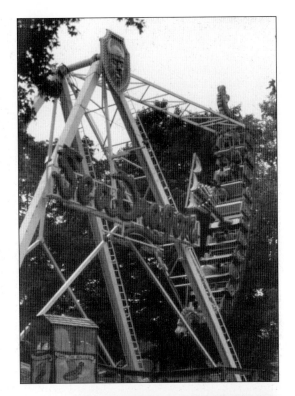

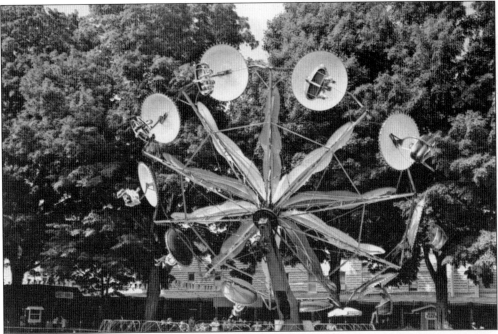

In 1981, the original 1965 Paratrooper was replaced with a newer version, which was placed on the corner of the Free Act Lawn, next to the Skywheel. Putting these rides on the Free Act Lawn helped to distribute the rides around the park more than before, when they were highly concentrated in the center of the park. (Katie Hilton Collection.)

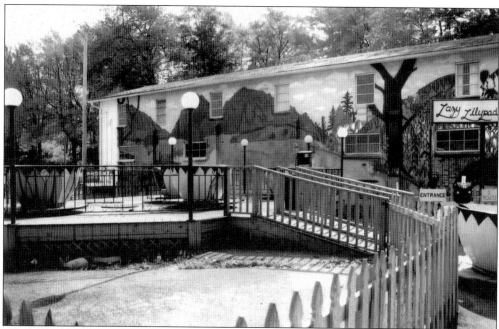

The Lazy Lily Pads was a ride similar to the Teacup ride at Disneyland and similar to the park's old Cuddle Up ride. Unfortunately, this was one of the rides that was auctioned off in 1992. (Jon Horning Collection.)

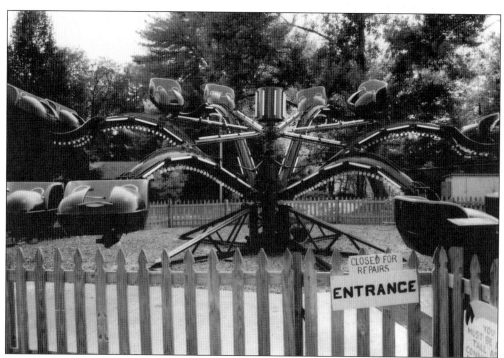

The Spider was similar to the park's old Octopus ride and also was built by the same company. Originally installed in 1970, the Spider was later auctioned off in 1992. (Jon Horning Collection.)

The Little Dipper continued to be one of Kiddieland's most popular rides throughout this era. This ride was built by the Alan Herschell Company.

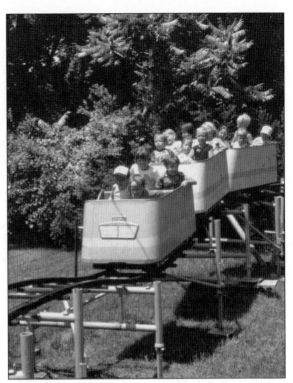

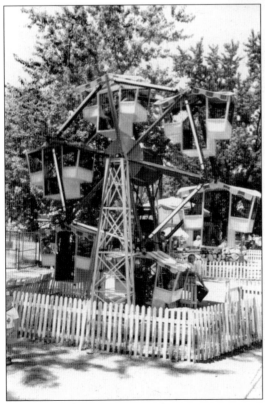

In the early 1990s, Kiddieland underwent major renovations. All of its gravel walks were replaced with concrete and new fences were built around all of Kiddieland's little rides.

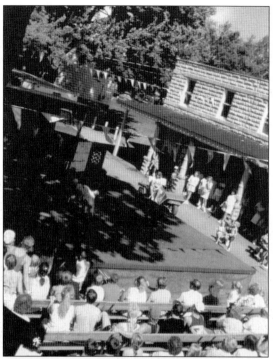

During the early 1990s, a small stage was built between Dreamland Ballroom and the midway buildings to serve as a venue for free entertainment. This stage replaced the old Free Act Stage, which had been replaced with a deck and fit in line with the park's new admission policy, whereby patrons were charged a fee to enter the park.

This photograph was taken on what was scheduled to be the last operating day for the Blue Streak. In 1992, when management decided to change the format of the park to focus more on water slides and concerts, it was also decided that the Blue Streak would be mothballed. The park's advertising urged the public to come take their last ride ever on the Blue Streak. Fortunately, an ownership change saved the Blue Streak. (Jon Horning Collection.)

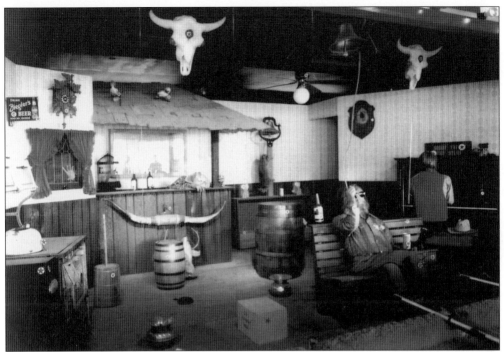

Krazy Kenny's Saloon was a shooting gallery located in one of the old storefronts of the old midway buildings. These newer shooting galleries were installed at many amusement parks and were equipped with the latest technology, using lasers on the ends of guns and electronic censors on the electrically operated gags. (Jon Horning Collection.)

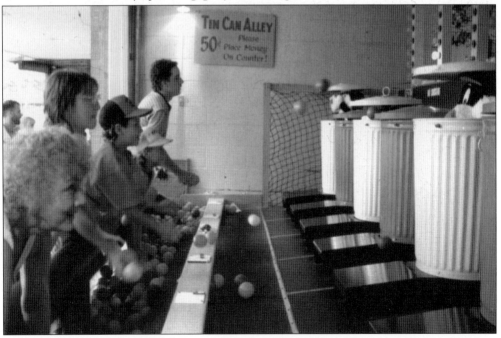

Midway games were a feature of the resort from the very beginning. These attractions still operate as a moneymaker for the park and offer patrons the chance to show their skill and win souvenirs.

A brand-new miniature golf course was introduced, located inside the miniature train tracks. This move was made to accommodate the construction of the Big Fun Deck. The new construction also necessitated the removal of the old Western-themed buildings of the miniature train ride. (Jon Horning Collection.)

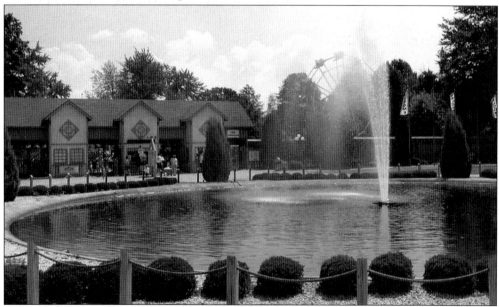

In 1992, Conneaut Lake Park celebrated its 100th anniversary. In preparation for the centennial exposition, in 1990 a new entrance was constructed with an early-20th-century theme. A new gate, landscaped gardens, and a reflecting pool and fountain formed the entrance. Although many people were not happy with the new fence and subsequent first-ever admission fee policy, the changes undoubtedly made the park cleaner and safer for patrons. (Courtesy loumuenz.com.)

After a few seasons of operating losses, management decided to change the format of the park, with a focus on some water slides, Kiddieland rides, and concerts. Most of the adult rides were to be auctioned off and the Blue Streak demolished. Fortunately, some local businessmen stepped in and purchased as many rides as they could to keep at the park, which they also purchased.

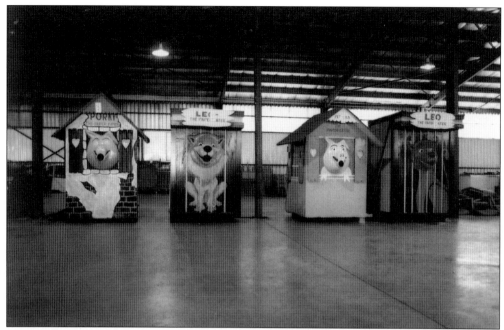

In addition to rides, miscellaneous amusement park items were sold at auction. Among the articles auctioned off were coin-operated arcade games, midway games, food equipment, and these paper eaters that once stood in the midway. (Jon Horning Collection.)

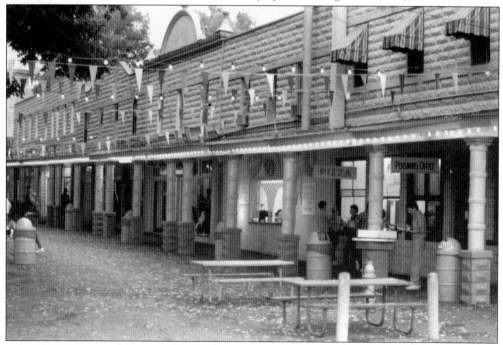

At the end of the 1992 season, management decided to demolish the old 1909 cement-block midway buildings, which severely needed roof repairs. In changing the format of the park, it was decided that the demolition of the buildings would widen the Free Act Lawn and create more room for concerts and festivals.

Five
THE NEXT ONE HUNDRED YEARS
1993 AND AFTER

After the new entrance gate was built, more rides were moved to that area of the park. Before then, this block of land was a parking lot. (Jon Horning Collection.)

From 1993 until 2001, the Devil's Den dark ride was known as Dr. Moriarty's Wild Ride. While the exterior of the ride had an altered look during this time, the interior was virtually the same. (David Hahner Collection.)

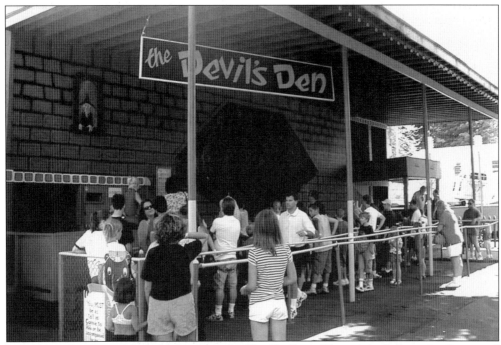

In 2001, volunteers gathered to restore the Devil's Den. The original sign was discovered underneath the building (behind a trap door), and the facade of the ride was spiffed up with a brighter color scheme. (Jon Horning Collection.)

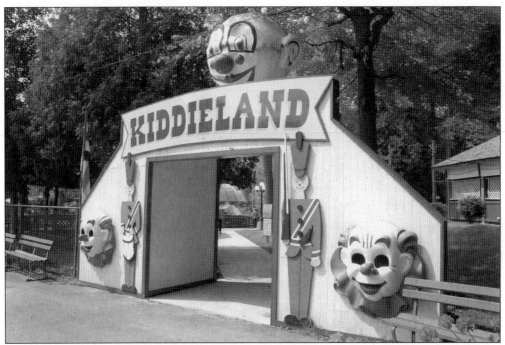

In 2002, the original miniature Kiddieland carousel, which had been auctioned off in 1992, was repurchased and reinstalled in Kiddieland. With the acquisition of the carousel, a new entrance was needed for Kiddieland. This entrance was modeled after the original, which had been demolished after the 1992 season. Fortunately, the old bobble head had been retained and was added to the new entrance. (Robert Brucker Collection.)

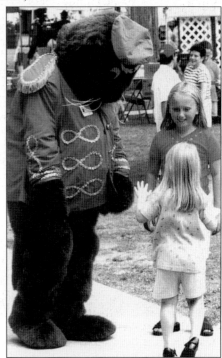

Connie Otter has been the official mascot of Conneaut Lake Park since the 1980s. In the past two decades, Connie has shared hugs with thousands of visitors. (Jon Horning Collection.)

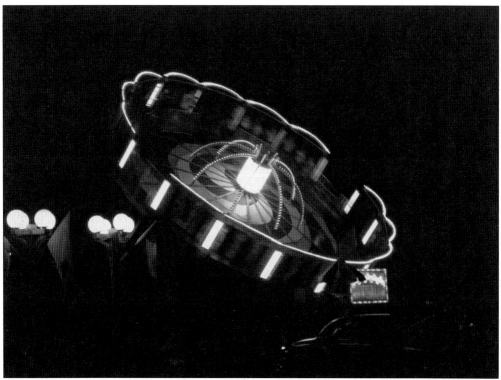

The resort was one of the first places in the area to install electric lighting. To this day, the park still looks magical at night. (Robert Brucker Collection.)

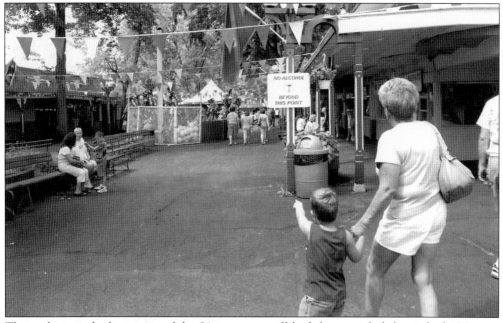

The midway at the beginning of the 21st century still had the same feel that it had 100 years earlier. It is overwhelming to think of the millions of people who have walked these midways throughout the resort's century-long history. (Robert Brucker Collection.)

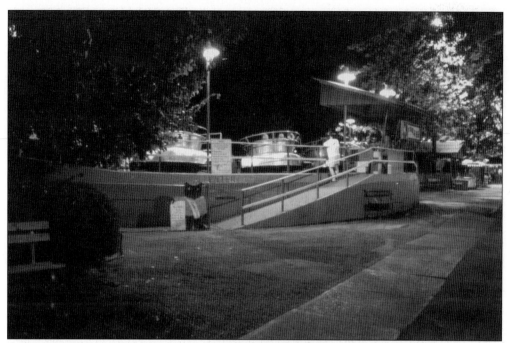

At 80 years old, this Tumble Bug is one of only a few that still exist. Due to the fact that Tumble Bug rides require a lot of maintenance, coupled with the fact that parts for these rides are no longer available, many parks removed the Tumble Bug from operation. Conneaut Lake Park retained this favorite, which from time to time has required the remanufacture of new parts.

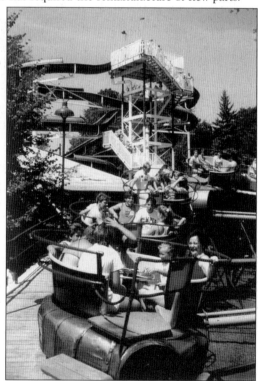

Cliffhanger Falls was built in a unique location for water slides: directly in the middle of the amusement park.

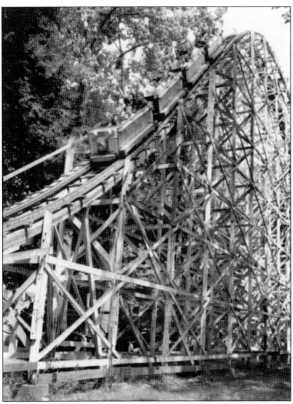

The Blue Streak did not operate for a few years in the 1990s; in fact it was added to a list of endangered coasters, classified as SBNO (Standing But Not Operating) by the American Coaster Enthusiasts. Conneaut Lake Park fell into bankruptcy and many were terribly worried about the future of this coaster. Fortunately, new management stepped in, restored the ride's stainless-steel trains, and reopened the Blue Streak in 1997 with a special celebration called Blue Streak Bash.

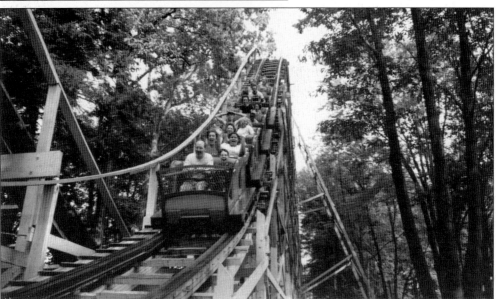

In 2004, enthusiasts again gathered to experience the Blue Streak and its original wooden train, which was pulled out of retirement in 2002. For the last 30 or so years, this original train was used only for maintenance purposes to "wear in" the track before opening in the spring. This is one of the few original wooden roller coaster trains still operating in the world that use leather seat belts as safety restraints. (Jon Horning Collection.)

The Blue Streak has long been an underrated roller coaster, probably because so much of the ride is hidden in the woods. In roller coaster jargon, the Blue Streak is known as an out-and-back ride. Out-and-back rides leave the station, go out to one point, turn around, and head straight back to the station. In the spring of 2002, enthusiasts, volunteers, and supporters gathered to paint the Blue Streak's loading station and lower support sections. (David Hahner Collection.)

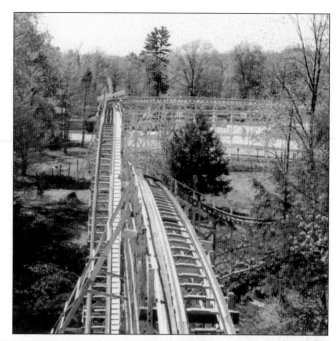

While modern-day coasters seem to get lost in the shuffle as people search for the biggest, fastest, tallest, or something-est, the Blue Streak offers a wonderful view into the past to see where things began. The American Roller Coaster Enthusiasts (ACE) designated the historic Blue Streak an ACE coaster classic in the early 1990s. While similar coasters have been modernized with new trains, safety restraints, and breaking systems, the Blue Streak remains virtually unchanged. (Robert Brucker Collection.)

In 2003, the first Holiday in the Park was held at Hotel Conneaut, where more than 100 trees were decorated in and around the hotel by local families and businesses. The annual Holiday in the Park is truly a community event, bringing people together for the holiday season and providing yet another reason to spend time at Conneaut Lake Park.

The Fall Pumpkin Fest is an Octoberfest-type event that has been held in the Conneaut Lake area since 1990. In 1999 the Fall Pumpkin Fest moved to Conneaut Lake Park, which proved to be a more fitting place for the event.

The 1994 Weekend Oldies Fest featured car cruise-ins, disc jockeys spinning "platters," and oldies groups in concert. When the park was closed in 1995, local businesses continued the activities and renamed the event Do-Wopp Fest. Today, the park hosts the Do-Wopp Fest on both the Memorial Day and Labor Day weekends, and every Friday night during the season a cruise-in is held on the Free Act Lawn.

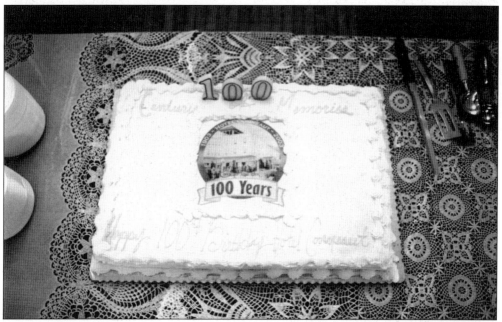

In 2003, Hotel Conneaut celebrated its 100th anniversary. The Conneaut Lake Historical Society threw a birthday party, offered a historical play written about Hotel Conneaut, and had a specially decorated birthday cake.

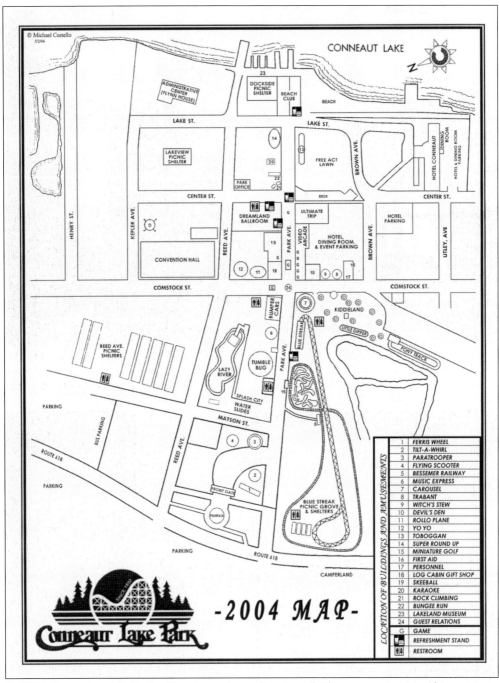

In 2004, Conneaut Lake Park offered a modest collection of rides, amusements, and attractions. One of the greatest features of amusement parks is that they are never complete.

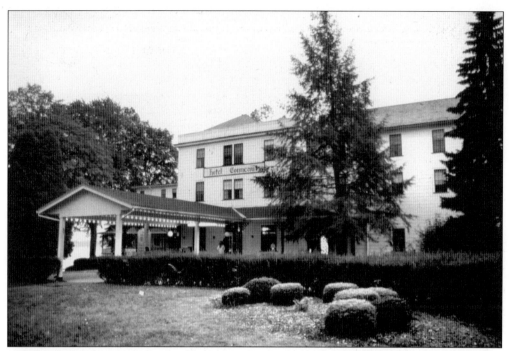

Hotel Conneaut continued to be the center of accommodations in the resort area well into the new millennium. Its grand old feel continued to draw people, even though it still did not have modern conveniences such as air conditioning, in-room telephones, and television sets. This may be the reason why so many return to the hotel year after year.

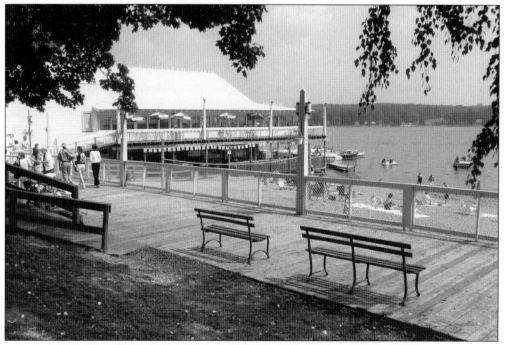

Even in the new millennium, Conneaut Lake Park's timeless charms continue to be well appreciated at the century-old resort. (Robert Brucker Collection.)

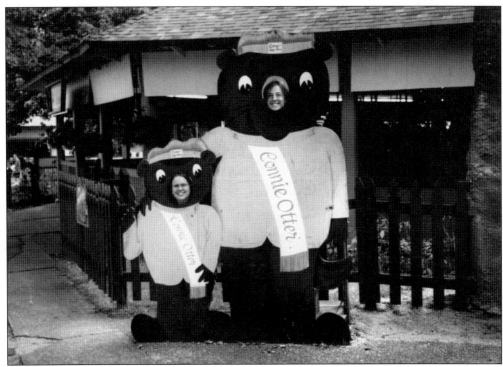

In 2002, the old Connie Otter cutouts were pulled from retirement and put back on the midway. Perhaps the future of Conneaut Lake Park will consist of more of these changes—building a future while embracing the past.

BIBLIOGRAPHY

Bush, Lee O. and Richard F. Hershey. *Conneaut Lake Park: The First 100 Years of Fun*. Fairview Park, Ohio: Amusement Park Books, 1992.

Conneaut Lake, thru a Century 1858–1958. Bicentennial booklet.

Futrell, Jim. *Amusement Parks of Pennsylvania*. Mechanicsburg, Pennsylvania: Stackpole Books, 2002.

Hilton, Don. *Sailing through Time: A Guide to Conneaut Lake's Passenger Boats*. Conneaut Lake, Pennsylvania: Don Hilton, 2002.

Johnson, David V. *History of Conneaut Lake, Pa. and the High Street Church Congregation*. Conneaut Lake, Pennsylvania: 1996

Luty, Bronson B. *The Lake as It Was: An Informal History and Memoir of Conneaut Lake*. Meadville, Pennsylvania: Crawford County Historical Society, 1994.